Images of America
Priest River and Priest Lake
Kaniksu Country

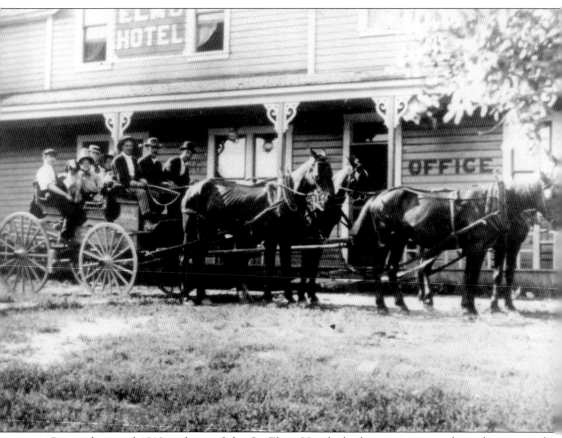

Pictured around 1910 in front of the St. Elmo Hotel, the horse stage was the only source of transportation to Priest Lake from Priest River prior to the automobile. Before 1910, it was an arduous journey that required an overnight stay at the Prater Halfway House. Later, with improved roads, it became a one-day trip. When Charles Beardmore replaced the horse stage with an automobile, he made the trip to Coolin in six hours!

ON THE COVER: This celebrated photograph of Charles W. Beardmore's motorstage at Priest Lake came from a postcard with a June 17, 1914, cancellation. At the time of the photograph, passengers were headed from Priest River Village to Coolin. Beardmore purchased the White automobile earlier that year in Spokane, Washington. The vehicle was robbed by three masked men outside Priest River Village in September 1914. Hugo DeWitz was the driver, and his son Milton DeWitz is the young man standing on the running board.

IMAGES of America

PRIEST RIVER AND PRIEST LAKE
KANIKSU COUNTRY

Marylyn Cork, Jeanne M. Tomlin,
and Diane E. Mercer

ARCADIA
PUBLISHING

Copyright © 2012 by Marylyn Cork, Jeanne M. Tomlin, and Diane E. Mercer
ISBN 978-0-7385-8919-0

Published by Arcadia Publishing
Charleston, South Carolina

Printed in the United States of America

Library of Congress Control Number: 2011934080

For all general information, please contact Arcadia Publishing:
Telephone 843-853-2070
Fax 843-853-0044
E-mail sales@arcadiapublishing.com
For customer service and orders:
Toll-Free 1-888-313-2665

Visit us on the Internet at www.arcadiapublishing.com

*To all the men and women who have shared their memories
and photographs that made this book possible*

Contents

Acknowledgments		6
Introduction		7
1.	Growing Our Communities	9
2.	Pioneers Blazed the Way	27
3.	Our Economic Heritage	41
4.	From Trees to Lumber	57
5.	On the Road to Progress	91
6.	Year-Round Playground	105
7.	Hard Work Yields Healthy Harvests	119

Acknowledgments

The Priest Lake Museum, the Priest River Museum and Timber Education Center, and Preserving Priest River History LLC would like to thank the Forest Service, Northwest Museum of Arts & Culture, Boise State University, University of Idaho, Ross Hall Studio, Hank and Charlotte Jones, Mary Will, John and Connie Salesky, and everyone who has shared their stories, gifted photographs to the museums, and provided information.

Unless otherwise stated, all photographs are the property of the Priest Lake Museum and the Priest River Museum and Timber Education Center (Preserving Priest River History LLC).

INTRODUCTION

Until the 1880s, the Priest River Valley (Kaniksu Country) on the west side of what is now Bonner County, Idaho, was an unpopulated wilderness that rarely saw a white man. While the Kalispel Indians were seasonal visitors who came to hunt, gather, and fish, they maintained their permanent villages along the Pend Oreille River, into which the Priest River flows near the town of Priest River. Today, their reservation lies downstream on the Pend Oreille River at Usk, Washington.

David Thompson was the first white man to travel through western Bonner County and its eastern Washington neighbor Pend Oreille County. Thompson was a Hudson Bay and Northwest Company explorer, mapmaker, and fur trader who led a brigade of Canadian voyageurs down the Pend Oreille River in 1809, making repeat trips through 1812. He did not venture up the Priest River, however.

Missionary priest Fr. Pierre DeSmet and his Jesuit colleagues were the next white men in the area. Beginning in 1844, they traveled through converting Northwest tribes including the Kalispel. According to local lore, the word "Kaniksu" is a Kalispel word meaning "Black Robe" or "Priest."

Today, the town of Priest River is the largest community in the west county with a population of about 1,800. Its first settlers were Germans Henry and Elizabeth Keyser, and Elizabeth's sister Kreszenz Kramer and brother-in-law Franz Kramer, who arrived in 1888 and 1889.

The first post office was established in 1891, just upstream on the Priest River from its confluence with the Pend Oreille River. The first village was also in that area, east of both the present town and the Priest River, in the vicinity of Keyser's Slough. The settlement was briefly called Valencia. The flood of 1896 forced the settlement to relocate to higher ground on the west side of the Priest River.

While the early settlers came from all over the United States and European countries, Priest River was long known into the 1950s as "Little Italy" because of the large number of Italians from southern Italy who began arriving in 1892. They came first to build the Great Northern Railway east and west from the town of Priest River and then to establish homes and farms east of the Priest River. That migration lasted until about 1920.

Until recent years, the mainstay of the economy in all of Kaniksu Country was primarily timber, and Priest River was long a wide-open logging town. The industry still fulfills an important economic role, and all of Priest River cringes to hear of another sawmill going out of business. Tourism is currently up-and-coming, but that has been true for the Priest Lake communities for many years. The lake is one of northern Idaho's celebrated "Big Three," boasting clean water, clean air, beautiful mountains, abundant wildlife, and other attractions.

The village of Nordman was named for John Nordman, an early pioneer who was born in Sweden. He settled the area north of Priest Lake in 1892 and was soon joined by miners and homesteaders who formed the small isolated community. A post office was established in 1916,

and the special mail carrier traveled 12 miles down lake by boat to Coolin to collect the mail, then walked three miles back to Nordman. A fire in 1926 destroyed the post office, ranches, and businesses, and the town was relocated to its present site on Highway 57 near Reeder Creek.

By 1900, the small village of Coolin had become the gateway to Priest Lake, where the arduous trip from Priest River ended on the south shore, and travelers relied on rowboats or steamboats to take them around the lake. Originally named Williams, this growing community of miners, trappers, and homesteaders was platted in 1907 by Andrew Coolin. Early businesses included two stores, two hotels, a marina, sawmill, and numerous saloons. The first Forest Service Ranger Station was built here in 1906. The Kaniksu National Forest is now part of the Idaho Panhandle National Forests, headquartered in Coeur d'Alene; the Priest Lake Ranger Station is located in Nordman.

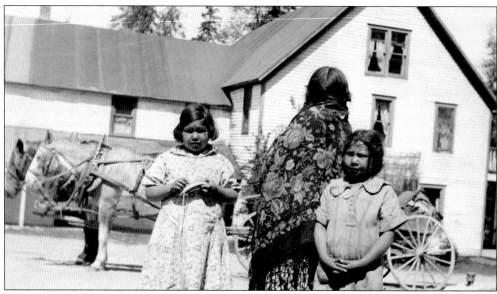

Kalispel Indians were among the first to recognize the bounty Priest Lake had to offer. By the late 1800s, they made their way from tribal lands at Usk, Washington, over the mountain to fish, hunt, and pick huckleberries at the lake. It has been determined they had as many as 11 campsites around the lake. In the 1920s and 1930s, the Indians traded huckleberries, smoked fish, and deer-hide moccasins for sugar, flour, and other needs. They arrived in midsummer and stayed through the October run of whitefish.

One
GROWING OUR COMMUNITIES

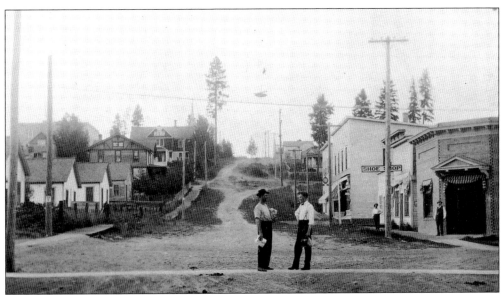

Priest River's Main Street is just two blocks long. Theodore "Ted" Hill, on the right, stands at the intersection of Main and High Streets, talking to an unidentified man. The rough track up the Third Street hill is now a paved street. Hill came to Priest River in 1913. By 1926, he had partnered with E.E. Robinson in the People's Market in the Wright Building, not shown behind Hill in this pre-1922 photograph. Constructed in 1910, the brick Citizen's State Bank on the right still stands. The house on the left just beyond the four little frame houses is the Charles Johnson home, which also still stands. The present Highway 2 to Newport, Washington, cuts through town just behind that house. The original road from Sandpoint to the east, followed the Goat Trail from Laclede, wound through the Italian Settlement, crossed the Pend Oreille River in town, and reached Newport via the present Old Priest River Road.

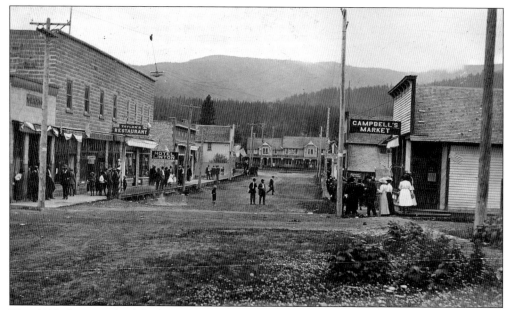

This 1912 photograph of the lower block of Main Street shows C.W. Beardmore's St. Elmo Hotel to the south. Campbell's Market is on the right, and the one-story building on the left is Harvey Wright's pool hall. A second story was added to the Wright Building later, originally constructed in 1907. The Wright Building burned in 2010. In 2011, the property became a new park.

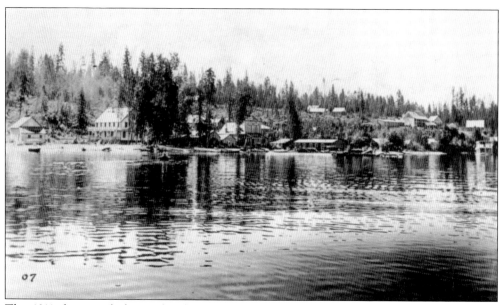

This 1911 photograph shows a bustling Coolin waterfront with two hotels, two stores, a marina, saloons, several homes, and the Forest Service headquarters. For many years, it was the gateway to all of Priest Lake, providing transportation, supplies, and housing for miners, trappers, settlers, and vacationers until additional roads were built in the 1920s.

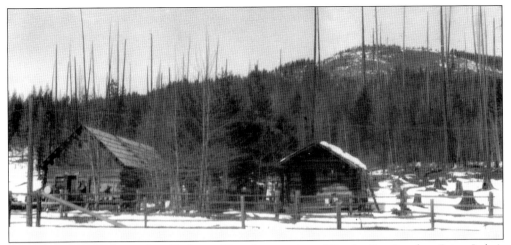

Today, Nordman is located on Highway 57 at the junction of Reeder Bay Road on Priest Lake's west side. The original village was established about 1892 by John Nordman, who mined in the area for several years before proving up on his homestead. A forest fire in 1926 destroyed the original school and post office, along with several businesses and ranches. The present community was rebuilt on a new site.

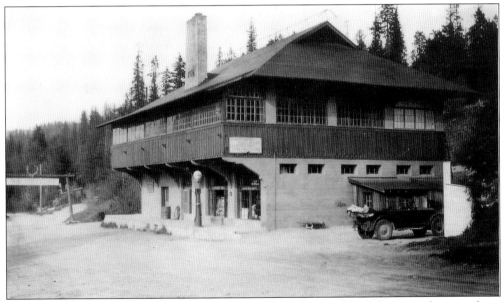

Few historic landmarks are as nostalgic as Priest Lake's Leonard Paul Store on the waterfront at Coolin. Built in 1926, the two-story structure was family owned until 1970. A popular dance pavilion with a large stone fireplace once occupied the second floor. The sign to Paul-Jones beach, formerly a thriving resort, is visible in the background. Today, the old pickle barrel and miners' tools have given way to frozen food, gift items, and a modern deli, but the charm remains intact.

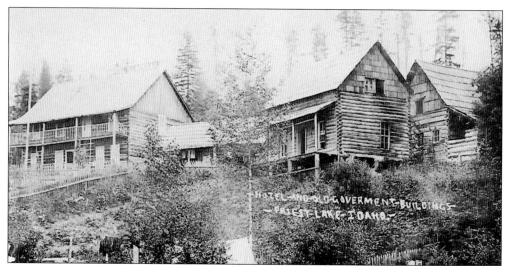

This c. 1910 photograph of Coolin shows the Klockmann Hotel (originally the Northern Hotel) on the left with Forest Service buildings on the right. The Kaniksu National Forest headquarters included a log office with the ranger's family home behind, a barn for the pack train, and a boathouse on Priest Lake's shoreline. Albert Klockmann located and developed the Continental Mine.

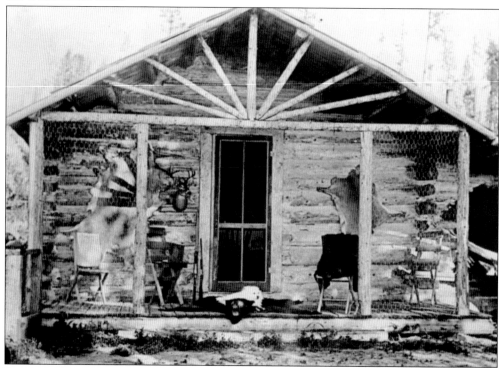

Ranger Calvin Huff built the original log cabin on the Warren homestead at Priest Lake where he lived for a time. The structure was later incorporated into a larger, more modern home for the William Warren family. Signs of the pioneers' hardscrabble existence are evident in the animal hides and rifles by the front door. Professional photographer Frank Palmer took this picture around 1910.

Photographs of the Priest River Hospital are hard to find. Here, the hospital appears as the large white building on the right. The old jail is the small white structure beyond it, which was something of a town joke. (It was not very escape-proof.) A blacksmith shop occupies the space in front. The photograph may have been taken from the window of the Hotel Linton.

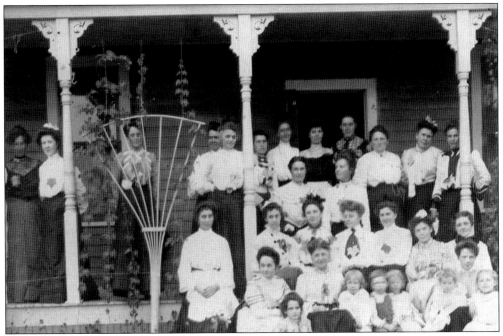

This group of lovely ladies was photographed in 1904 at a house party at the Gumaer home in Priest River. Unfortunately, the identities of most have been lost to history, but the group of women includes Ella Mears, Lucy Beardmore, Josephine Gumaer, Grace Bolling, and Dorothy ?.

One of the first frame houses in Coolin, Leonard Paul's home overlooking Priest Lake was built in 1912. Paul's original log store stood in front of the house. The home became the social center of the community after his 1914 marriage to Vera Moore of Blue Lake. She landscaped the grounds so beautifully that some thought it was a park. The residence burned to the ground in 1990.

The Cultus Club was a women's cultural and civic organization active in Priest River for many years. The word "cultus" stood for culture, not "cult," as some newcomers posited a few years ago. The club had a hand in just about every city improvement project undertaken and sponsored many educational programs and entertainments. Cultus Club Park was the name originally suggested for Priest River's city park.

Members of Nell Shipman's movie company visit with Belle Angstadt at the Lone Star Ranch near Bear Creek on Priest Lake. Angstadt and Shipman are seated in front; Shipman's son Barry is crouching at left, on Belle's right. Others in the photograph include Fred and Joseph Gumaer of Priest River, Belle's sister and husband, and members of Shipman's film crew. (Photograph courtesy of Boise State University.)

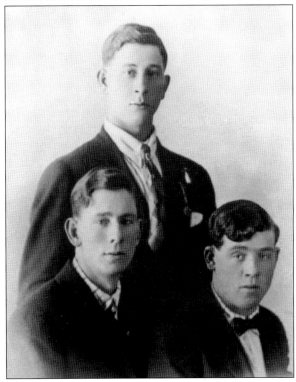

John Caprai (in back), Howard Koffel, and Robert Doolittle were photographed together on August 7, 1918, going "off to war." Caprai, a businessman, served as mayor of Priest River in his later life, and Doolittle owned a sawmill and served in the Idaho Legislature. The Doolittle sawmill was located on the site of the present Priest River Lamanna High School. Nothing more is known of Koffel.

Located on Eight Mile Island, the Vinther-Nelson log cabin represents construction techniques used at Priest Lake during the late 1800s. Built in 1897 to shelter owners of a nearby mining claim, it was purchased by Samuel Vinther and his cousin Nels Nelson in 1900. Listed as a National Historic Site, it is operated by the Forest Service in cooperation with descendants of the Nelson-Vinther families.

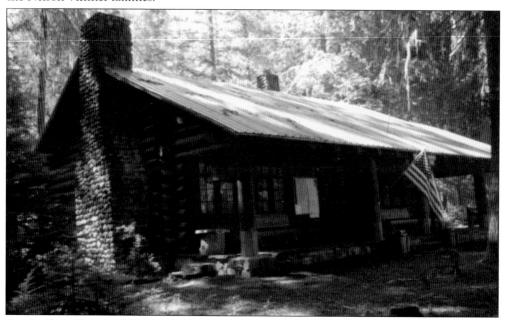

Originally built in 1935 by the Civilian Conservation Corps for the Forest Service, this rustic cabin is now an interpretive visitor center maintained by the Idaho Panhandle National Forest and the Priest Lake Museum. Exhibits depict the lake's rich history, including logging, mining, homesteading, steamboats, and wildlife. Declared the best volunteer museum in Idaho by some historians, it is open from Memorial Day through September.

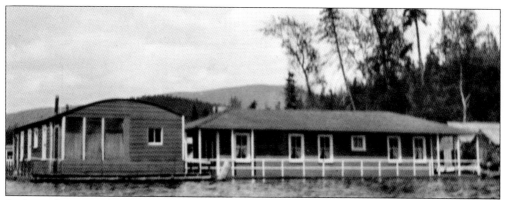

In the early 1900s, there were many types of float houses on Priest Lake but none more elaborate than John Schaefer's summer home at Coolin. Schaefer's home featured a fireplace and a large veranda for entertaining. On a smaller scale, logging operators towed multipurpose float houses around the lake as convenient shelter and cookhouses for their workers.

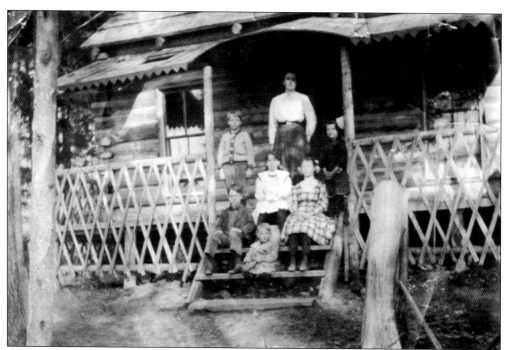

Priest Lake's first school was established in 1905 on Soldier Creek at the south end. Four years later, the school was relocated to a site just north of Coolin. In 1916, a one-room frame schoolhouse was built on the hill above Coolin. It became the civic center when the combined school was constructed in 1961.

Built in 1916, this white frame school in Coolin housed grades one through eight. A former student said, "I learned more in that one room than I ever could have anywhere else. When we finished our lessons, we listened in on the older grades or helped young ones with reading or spelling." During cold winter days, the teacher would make soup on the wood stove for their noon meal.

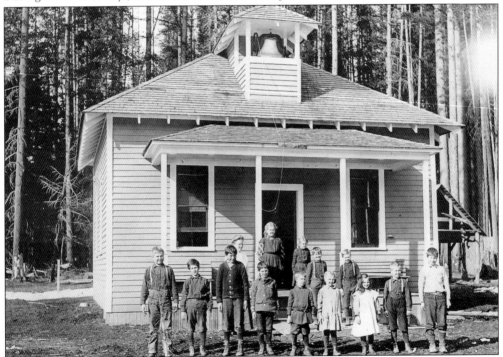

This white frame school at Nordman, three miles north of Priest Lake, was constructed in 1927 after the original log school burned. When 18-year-old Rose Chernak arrived at Priest Lake in 1917 to teach at Nordman, she boarded with the Kerr family. She walked more than a mile to school, often returning home in the dark. The rural school also served as a gathering place for meetings and socializing.

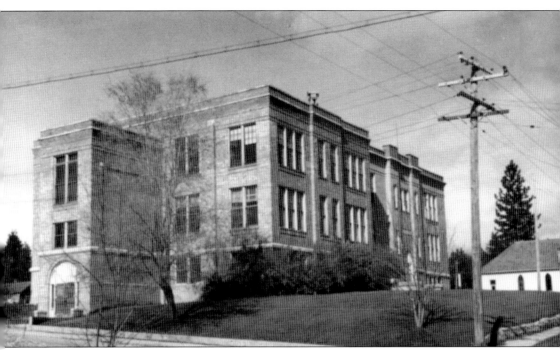

Priest River's old brick school building stood on the corner of Fourth and Jackson Streets where the current Frank Chapin Senior Center is located. The wood frame structure in the background was the original Catholic church. The photograph was probably taken around 1940, before the new and current St. Catherine of Siena Catholic Church was constructed on the same site. The frame church was purchased by the Latter-day Saints and moved to the corner of Fourth and Dixon Streets, where it is now occupied by the River City Christian Fellowship. Peter J. Young built the brick school in 1914 and added on to it in 1920. The high school occupied the top floor; the lower grades occupied the bottom floor. The structure was demolished in 1972.

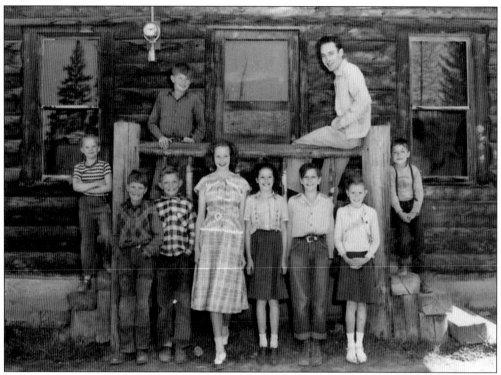

Built by the Works Project Administration in 1934, the one-room Lamb Creek School at Priest Lake operated until 1961 when the combined Priest Lake Elementary School opened. The building was a teacherage until 1973, when it was remodeled to become the Priest Lake Library. Shown here is the class of 1948–1949 with teacher Richard Timm.

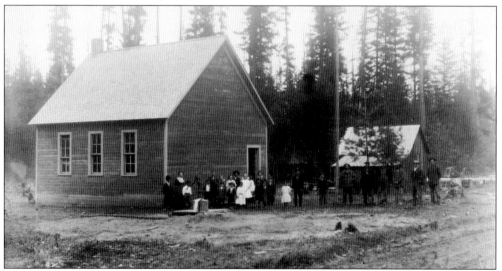

Rural school buildings once dotted Bonner County. They were typically located within walking distance of most of their students who either had to walk or ride a horse to reach them. The Stewart School was located on Shaw's ranch east of the Priest River. It was named after pioneer Frank A. Stewart who donated the property on which it stood. It later served as the Settlement Grange Hall and is now in private hands.

The Freeman Lake Fire, which swept across the peninsula in August 1931, destroyed the first Meegan School in the Blue Lake District. According to one story, the fire may have been set by a lightning strike or an overturned still. The inferno destroyed timber, farms, schools, and just about everything else in its path but without the loss of human life. The school was named for Bill Meegan, who homesteaded a 140-acre farm on Meegan Creek north of Blue Lake. Teacher Miss Young is shown here with the student body in 1909. Most of the children were related. They included Sivilla Huff, Art Moore, Fife Moore, Benton Prater, Myrtle Huff, and Bill Huff, in no particular order. The second Meegan School is now a relic on East Side Road.

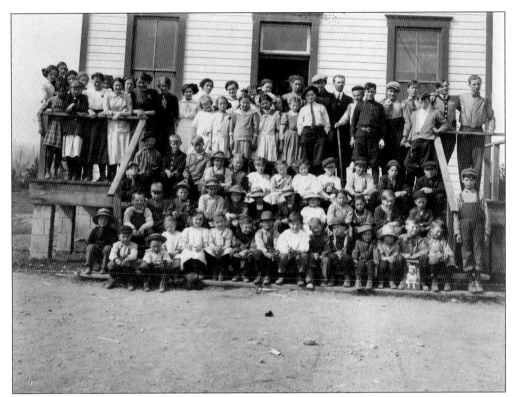

The student body of the Priest River School in 1913 included Vivienne Beardmore (McAlexander), the sixth child from the left in the front row. The rest are unidentified. This frame building accommodated children through tenth grade. An earlier log building housed the first school, near the confluence of the Priest and Pend Oreille Rivers. In 1896, the village was relocated to higher ground to the west because of flooding.

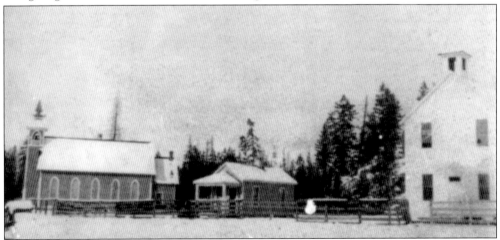

On the left, St. Anthony's Mission Church was located about three miles east of the Priest River in the Italian Settlement. The Settlement School building is on the right with the teacherage between them. The school burned in 1922 and was replaced with a brick structure, now a National Historic Site. The children began attending classes in town in 1939. The church was demolished after its parishioners began attending services there as well.

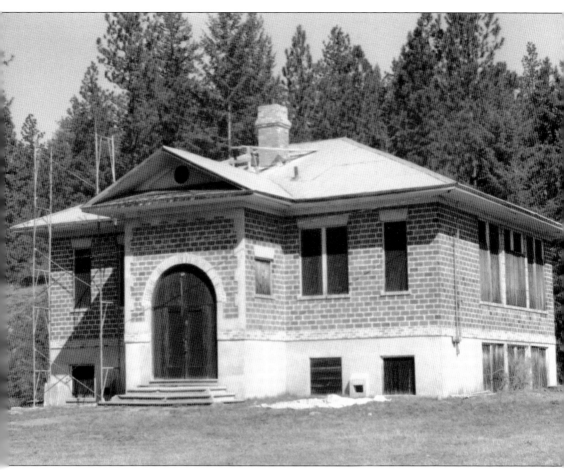

This 1999 photograph of the "new" 1922 Settlement Schoolhouse was taken as the current owners (the Knights of Columbus of St. Catherine's Church) were beginning a several-years-long project to restore the building. The Settlement School District consolidated with District No. 13 in Priest River in 1939, and its students transferred to town. The building is in the National Register of Historic Places and is now used for various community events.

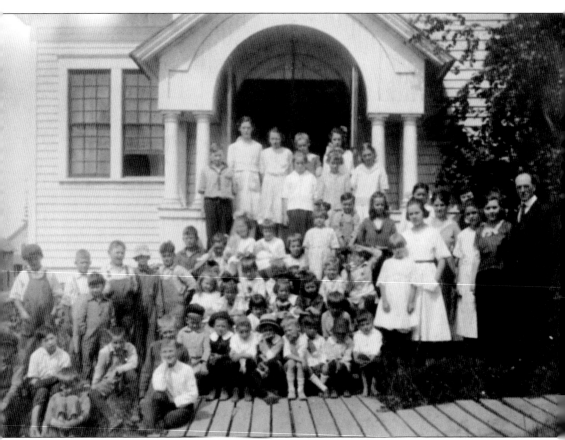

Born in 1905, Vivienne Beardmore, daughter of pioneers Charles and Lucy Beardmore, was around 16 years old when this photograph was taken of the Congregational church's Sunday School. She is standing on the right side of the photograph, next to who may be the pastor of the church. All others are unidentified. The building shown was dedicated in 1903, but its religious work in the community began in 1894 with Jacob C. and Eva Finstad, W.M. Wiser, and James Kilpatrick Sr. This historic building was torn down in 1983. It had served as a hospital for influenza patients during the epidemic that followed the Great War, and was used as temporary classroom space while a new high school was being constructed in 1940.

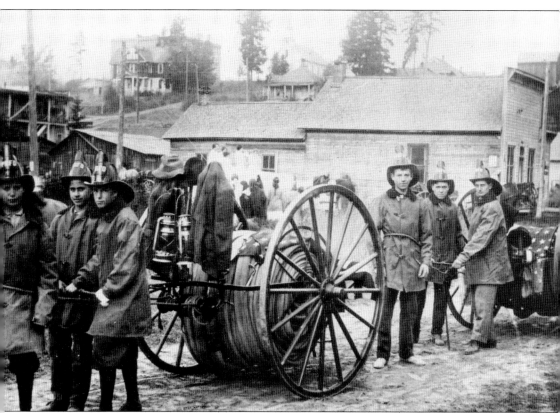

Arley Stewart said there were once four of these carts stationed in various locations around town. When the siren blew, indicating by the number of blasts where the fire was, everyone made a mad scramble for the nearest hose cart. Whoever reached the cart first hauled it to the fire and received a small payment for doing it.

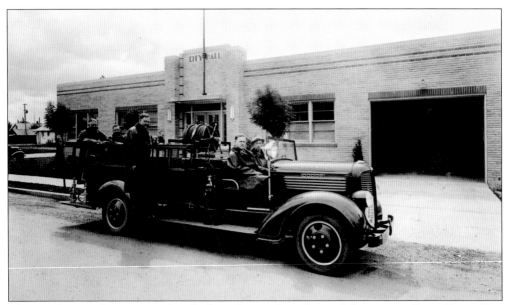

These volunteer firemen stand with their fire truck in front of the current Priest River City Hall, constructed in 1937. From left to right are Jack Slocum, George Binkley, Maurice Lathrop, E.M. Perin, and Harry McGee. The fire truck was housed in the empty space on the right; it was a tight fit. A new fire hall now stands on Cedar Street, behind city hall on High Street.

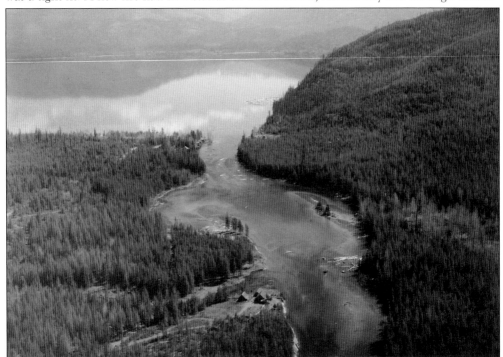

This aerial view of the outlet before the Outlet Dam clearly shows the confluence of Priest Lake and the Priest River. In the upper right is a boom of logs, which was released in the spring when the log drives took them down river. Also shown are a few early cabins and a small mill. The power company Northern Lights Cooperative built a dam across the river in 1957.

Two
Pioneers Blazed the Way

Thomas Benton, a native of Indiana, served in the Civil War with the 16th Illinois Cavalry Company K, and survived 18 months in notorious Andersonville prison camp in Georgia. He moved west with his wife and four children in 1890. She died of tuberculosis later that year. Tom homesteaded on Benton Creek but was unable to prove up on the property because it actually belonged to the Great Northern Railway. He then moved to the Prater Halfway House, owned by his daughter Effie Noble Prater and her husband, James Taylor Prater. The cabin became the Benton Ranger Station. Tom died in 1931.

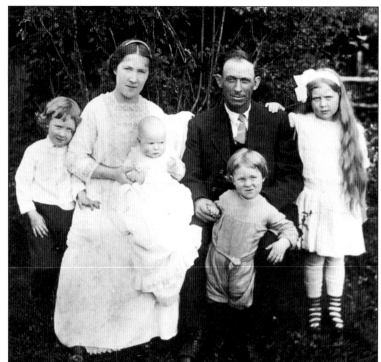

No one had a bigger impact on early-day Priest River than Charles W. Beardmore, a Wisconsin schoolteacher who arrived on the Great Northern Railway in 1900. He went into commercial enterprises and died of a heart attack in 1935 while trying to bring a pulp mill to town. He is shown here with his wife, Lucy (Gumaer). Their children are, from left to right, George, Raymond (in Lucy's arms), Curtiss, and Vivienne.

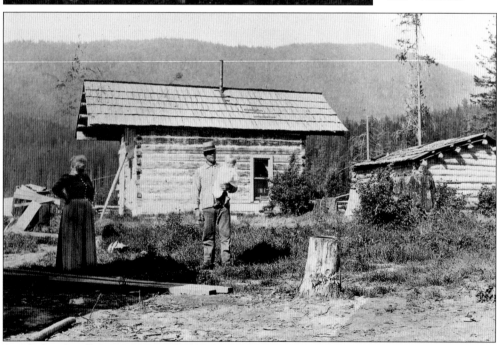

Sturdy Swede Albert Hagman staked his homestead claim in Snow Valley in the 1880s. Located between Priest River and Priest Lake, the valley was accessible only by trail over the hill from Newport. Two years later, Hagman brought his bride, Helena, to live in the dirt-floored, windowless cabin, and together they carved out an existence in the wilderness. Hagman died in 1944, but his many descendants still live in the area.

Arriving at Priest Lake from Michigan in 1892, Richard Handy applied for a homestead on 160 acres near the south shoreline of Soldier Creek. After Handy died in 1907, his widow, Ida, established the Idaho Inn at nearby Coolin. Later, son Harry developed Camp Sherwood, a prime vacation resort with wide, sandy beaches and a clear, shallow swimming area. When Harry died in 1949, the property was subdivided into private lots.

William "Daddy" Duffill emigrated from England and arrived at Priest Lake about 1917. Living in a float house on the Thorofare, he worked at Forest Lodge, cared for Nell Shipman's movie menagerie and even acted in one of her silent films. Duffill is second from the left with the pipe and his daughter Mary is in back with the camera. The rest are unidentified members of the Leonard Paul family.

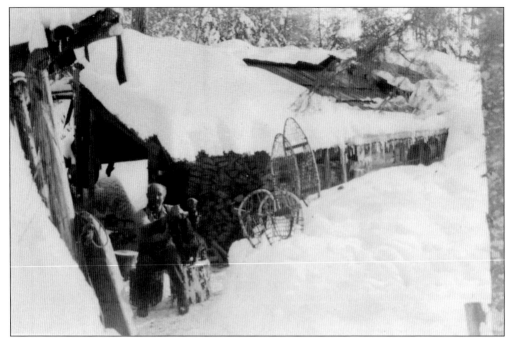

Lewis "Pete" Chase, one of Priest Lake's hardy pioneers, eked out a living as trapper, hunter, prospector, and moonshiner near Trapper Creek on the Upper Lake. His legendary exploits include an arrest during Prohibition by federal agents who found a 100-gallon still and 50 gallons of 140-proof whiskey at his isolated cabin. Chase drowned in the Thorofare in 1941 when he apparently fell overboard while attempting to start his motorboat.

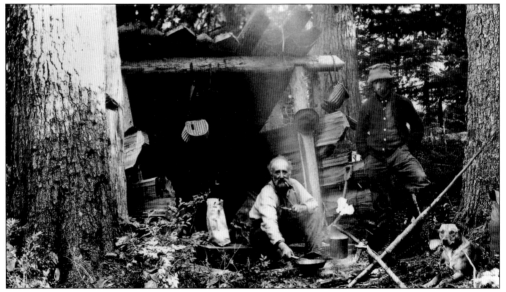

A former scout with General Custer, Edward "Dad" Moulton came to Priest Lake in 1898 and established several camps around the lake as he acted as guide, trapper, hunter, and prospector. He died in 1917 when his gun accidentally discharged as he was stepping out of his boat. His obituary described him as "truly a man of the west, always having a hearty greeting and a personality that made him friends by the score."

Andy Coolin, one of the first white settlers at Priest Lake in the early 1890s, homesteaded the south shoreline. For years, Andy continually searched for a profitable ore strike and was partner in several unsuccessful mining operations. He recruited money interests to build the Panhandle Electric Railway and Power Company to serve Priest Lake but the scheme never materialized. Coolin died nearly penniless in 1936 and was survived by his son Stewart.

Spokane photographer Frank Palmer took this photograph in 1910. The pioneer woman with a gun is not identified. The photograph shows a well-established log cabin decorated with antlers and snowshoes. Only a few hardy women tolerated the isolated existence at Priest Lake, where survival depended on hunting, gathering, and fishing. The long, harsh winters meant people might not see another person for months.

Entrepreneur Ida Handy arrived at Priest Lake in 1892 with husband, Richard, and children, Harry and Ruth. They homesteaded on 160 acres on Soldier Creek, in an area later known as Sherwood Beach. When Richard died in 1907, Ida bought the Idaho Inn, a two-story hotel in Coolin. She later built the Bungalow, a more casual eatery, and once owned the Great Northern Inn. Ida died at 76 in 1935.

In 1904, Leonard Paul's first store at Priest Lake was a log cabin. "If we don't have it, you don't need it" was his motto. A larger store built in 1926 remains one of the lake's landmarks. He was also a partner in the Paul-Jones Beach resort from 1920 to 1945. He died in 1971. His name still brings a smile to old-timers who remember his genial greeting, trademark cigar, and jaunty black beret.

This cabin on Coolin's waterfront served as the hub of operations for Slee's Marina from 1904 into the 1920s. Joseph Slee purchased waterfront property from Andrew Coolin and built the two-room cabin as summer quarters. Later on, he constructed a two-bedroom frame house for the family. On the left is Slee's paralyzed son, Walter, who piloted the W.W. Slee with the help of a fireman.

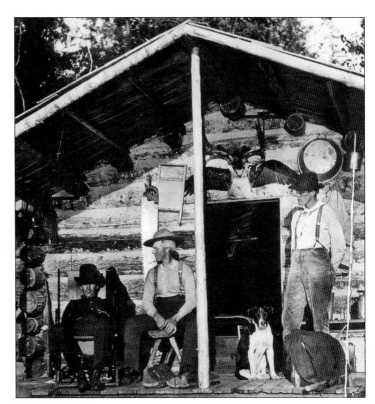

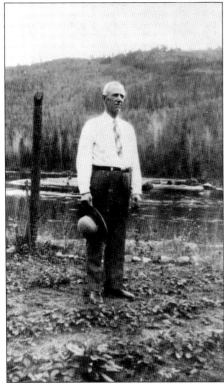

In 1917, Tony Lemley endured three trials before he was acquitted of murdering his Lamb Creek neighbor near Priest Lake. As Frank Green drove his team home, he attempted to take a shortcut through Lemley's property in spite of previous warnings not to. Both men opened fire, but Lemley's bullet scored the fatal shot. After his release, Lemley and his wife, Mary, moved to the outlet and ran a resort until his death in 1940.

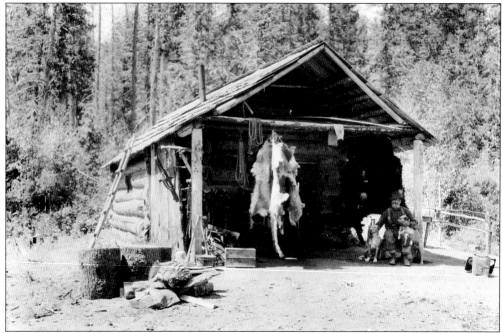

In the early 1900s, "sourdoughs" at Priest Lake made a meager living trapping and hunting while hoping to strike it rich working mining claims. Sourdoughs were named for the yeast starter used to make pancakes or biscuits, the mainstay of their diet in the wilderness. Shown here is Gus "Cougar" Johnson at his camp near the Thorofare.

James and Louisa Davis selected their homestead site near Cavanaugh Bay on the south end of Priest Lake in 1907. Shown here in 1910, they built this comfortable two-story log home where they raised their family. To obtain 160 acres of free land from the government, settlers had to live on the land for five years, clearing and improving it with buildings. For income, they often sold eggs, produce, and milk or worked in the mines.

Six Naccarato brothers and their sister, Rosa Bombino, were among Priest River's first Italian settlers after construction began on the Great Northern Railway in 1892. This c. 1914 photograph shows five of the brothers, from left to right, Mike, Joe, Charlie, Frank, and Tony. Angelo was the other brother. These tough, resilient men all farmed in the Italian settlement on the east side of the Priest River.

This Easter Sunday group stands in front of a boardinghouse (possibly the Kramers') in 1906. From left to right are Kreszenz Kramer, an unidentified woman and boy, Elizabeth Keyser, James Bryant, Frank Knowlton and an unidentified boy, Theresa Kramer, four unidentified, and Andrew Coolin. The woman in the doorway behind the group is also unidentified. Elizabeth Keyser and her sister Kreszenz Kramer (maiden name Fuchs, pronounced *fox*) were the first two white women in Priest River.

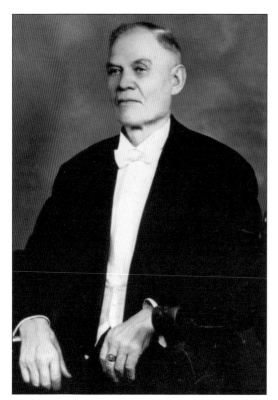

Pictured here around 1935, William "Bill" Torelle was one of two brothers who pioneered at Torelle Falls, long before Highway 57 was constructed past the picturesque tavern and café perched over a waterfall on the West Branch of Priest River. His brother Rudolph was the town's first schoolteacher, who taught in a log school building in the original village in the late 1890s.

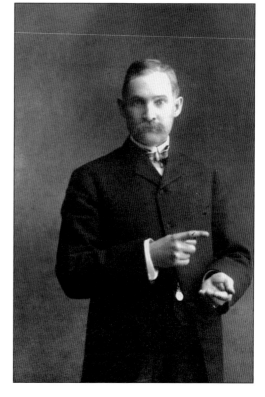

Shown here in 1900, Milan S. Lindsay is believed to have been Priest River's first practicing attorney, although no records exist to show he ever passed the bar exam in Idaho. He also dabbled in real estate and platted part of the town. According to some accounts, he might have owned a pole yard; however, his last name has probably been confused with that of the Lindley brothers, who sold poles.

Called "Grandma Stover," an appellation that seems to have been applied to many elderly women in the community, this woman emigrated west from North Carolina mountain country. According to an old-timer, now deceased, she is the "culprit" who introduced the noxious weed tansy to Priest River. Tansy was used for medicinal purposes.

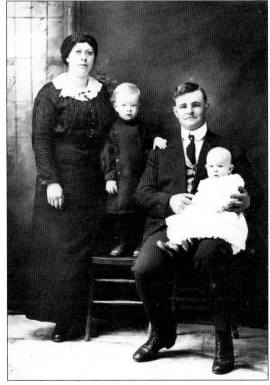

Glenn Stewart—shown here in 1909 with his wife, Della, and children Arley and Zella—was a son of pioneers Frank and Nancy Stewart. As a young man, Glenn surveyed for the Great Northern Railway around Priest Lake for a railroad that was never built and learned photography. He took many early photographs of Priest River and worked for C.W. Beardmore for 28 years.

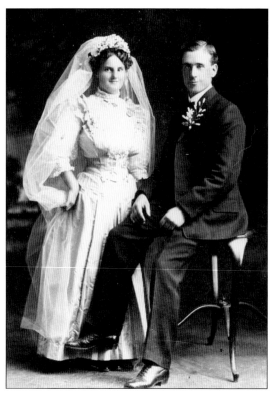

Theresa Kramer, daughter of pioneers Franz and Kreszenz Kramer, married logger Elmer Stone. Indian women camping at Keyser's Slough "stole" Theresa as an infant from the home of her aunt Elizabeth Keyser. When her mother arrived to claim her, she found a circle of Indian women passing the child around exclaiming about her white skin and fair hair. They willingly returned the baby to Kreszenz.

This pretty bride is Eva Spriggs, who married Norwegian Jacob Finstad in Iowa. Eva wore black, as many brides did then, so the gown could be worn at other dressy occasions. He was a charter member of the Congregational church, served one year in the state legislature, and grew vegetables and fruit. They homesteaded in 1894 across the Priest River from the present Evergreen Cemetery; they had 14 children.

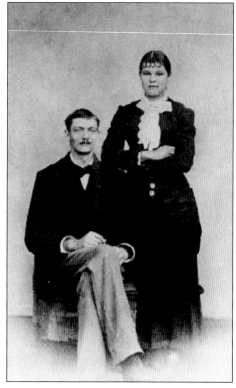

Helena Kuhnhofer married Henry Keyser Jr., son of pioneers Henry and Elizabeth Keyser, in 1914. Henry was a jack-of-all-trades—a carpenter, house painter, custom butcher, a farmer who did custom threshing for neighbors, a talented musician on the violin and accordion, and a square dance caller. He and Helena lived on a farm five miles north of Priest River on the road to Coolin.

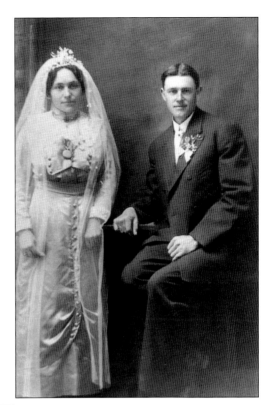

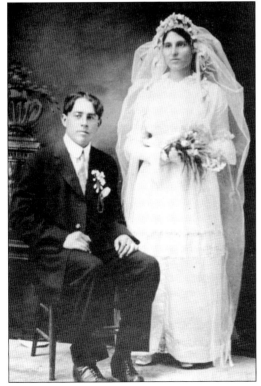

Born in Italy, Louisa Naccarato came to Priest River at age five with her father, Frank, and brothers Pete and Phil, leaving mother and sisters behind. Her aunt and uncle, the Charles Anselmos, raised her after Frank and Pete died. She married John Keyser in April 1914. Keyser died in 1926 after a four-day illness, leaving Louisa to raise four small children and run a farm by herself.

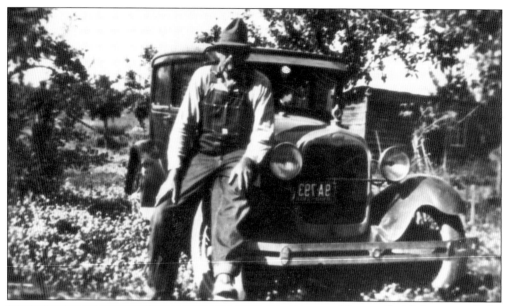

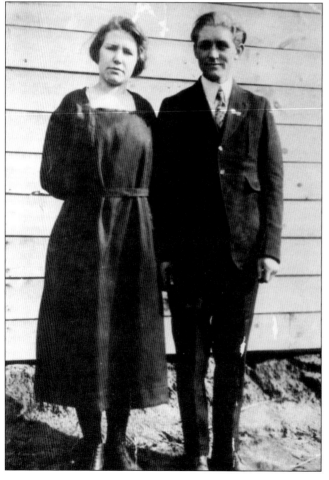

Monroe Smith homesteaded on the peninsula in June 1919 with his wife, Mullie, and their large family. They first lived in a tent and then in a house Monroe finished shortly after Mullie's death from tuberculosis in December. The peninsula (named by T.L. Pearsall) had just been logged by the Jurgens Brothers, and the entire Smith family did "brutal work" clearing their land. Monroe died in 1940.

Monroe Smith's daughter Annie Smith is shown here with her husband, Ernest Hammons, whom she married in 1922. Annie was the person to go to in her old age for information about the history of the peninsula. Her family was the first to settle there. Annie had great stories to tell of the hardships of those early days and vivid memories of the 1931 fire.

Three
OUR ECONOMIC HERITAGE

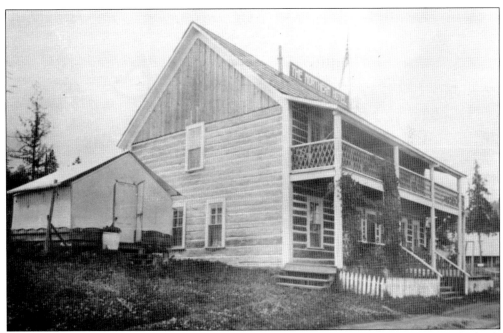

The first permanent building on Priest Lake was the two-story Northern Hotel at Coolin built in 1890 by the Great Northern Railway to lure tourists to this pristine wilderness. Over the years, the building has seen new owners and name changes but operates today as the popular Northern Inn Bed and Breakfast. Painstakingly restored, it features the original plank floor, stone fireplace, and windows overlooking the lake.

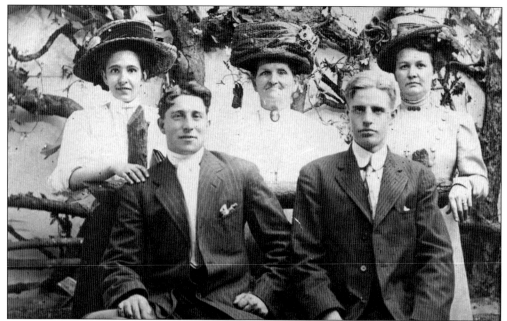

Ellen Baker, in the big hat standing between daughter Emily Williamson on her right and an unknown woman, owned and operated the Savoy Hotel; she was probably the most formidable woman ever to call Priest River home. She carried a handgun in her apron pocket and used it when the occasion demanded. She died in 1922 at age 83 inspecting her mining claim at Upper Priest Lake.

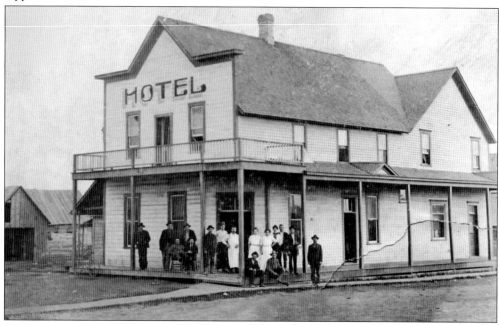

This was Ellen Baker's Savoy Hotel, located near the present bulk plant on Montgomery Street. It might originally have been called the Priest River Hotel. The name was changed when it was moved (and turned around) from its early site because it was on railroad property, and a new porch was constructed. At some time in its history, siding was applied over its log walls.

By 1907, widow Ida Handy owned the bustling Idaho Inn at Coolin near Priest Lake's waterfront. The first floor featured a spacious dining room, while guest rooms lined the second floor. At one time, she also owned the Northern Inn and Bungalow Restaurant on the waterfront. Handy later sold the Idaho Inn to the Hodge family, who operated it until it burned during the winter of 1942.

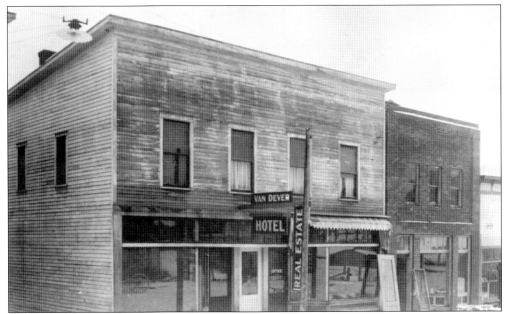

The Van Dever (pronounced *Vandevere*) Hotel on Priest River's Main Street burned in 1932 along with the Cozy Corners, a rooming house next door in which the fire probably started. According to one old-timer, "People said you could hear the bedbugs screaming." The brick building that adjoins it was once Bruno Bombino's beer parlor and also Gus Naccarato's pool hall. It still stands on Main Street across from the Beardmore Building.

Shortly after Hotel Charbonneau was constructed in 1911, Dora Charbonneau acquired sole ownership of the hotel in a divorce from her husband in Priest River. She operated the hotel for nearly 40 years. The hotel was noted for its tasty meals and fine accommodations that allowed Charbonneau to charge a bit more than competitors. She died in Spokane around 1950.

Sam Byars built this rustic, two-story Forest Lodge on the north shore of the Thorofare around 1914 to accommodate the growing number of fishermen, hunters, and vacationers who found their way to Priest Lake. The outbuildings included an icehouse, a barn, and guest cabins. Silent Screen star Nell Shipman and her crew stayed there in 1923 while building their compound on Mosquito Bay.

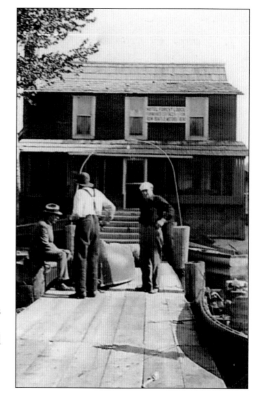

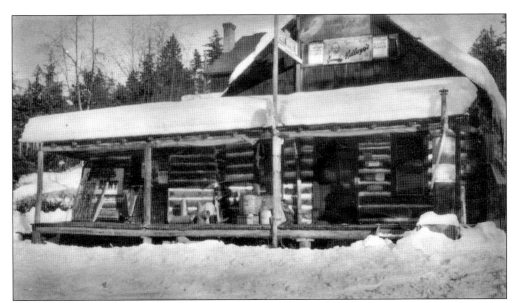

At 19 years old, Leonard Paul built Coolin's general store in 1906. It was a solid log building set into the hillside with a long, wooden porch across the front. Harriet Klein Allen recalled, "There were two long counters, a post office cage and a storage area. Name anything and he had it, boots, thread, lamp chimneys, crocks for sour dough. Crackers were in metal boxes, flour and sugar in huge sacks, stove pipe and round pink peppermints."

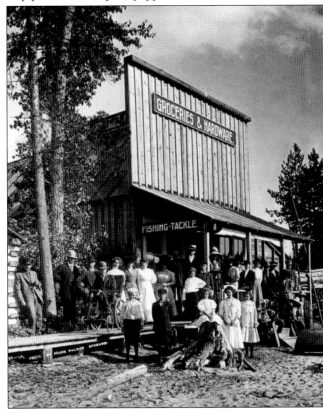

The Warren-Burch Store on Coolin's waterfront offered a variety of goods, such as groceries, hardware, and fishing tackle. This group was assembled for a Fourth of July celebration around 1910. The store was later sold to Michael Moore, who ran an ice cream parlor. It eventually became a storage facility for Art Moore's Marina.

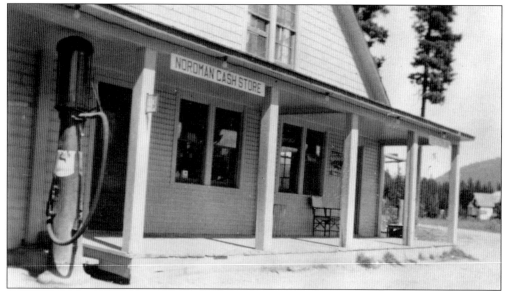

Originally located northwest of its current location, the village of Nordman was named after Swedish immigrant John Nordman, who arrived at Priest Lake in 1892. As more families populated the area, a store was established, a post office opened in 1916, and a school was built. When the highway was rerouted in 1948, the present community was developed near Reeder Bay Road.

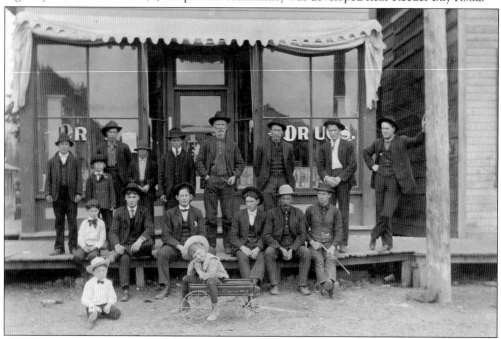

Shown here in 1906, Priest River Drug was the town's first pharmacy. The children in front are Edwin Gowanlock (left) and Earl Wilcox. Seated on the boardwalk from left to right are Paul Mears, Victor Murray, proprietor Earl Wilcox, Bert Lemley, Charles Carr, and the forest ranger at the Falls Ranger Station S.S. "Toots" McEwan. Standing in the back, from left to right, are four men of the Carey family, and Billy Jachetta, William Whetsler Sr., Michael "Happy" Houlihan, Jack Will, and Frank Knowlton.

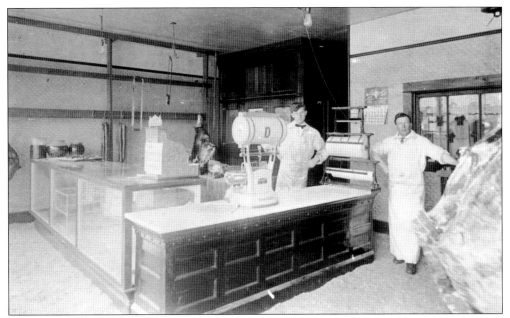

This 1913 photograph by Glenn Stewart shows Ted Hill on the left with then-partner Loren Campbell in a meat market located in the L.V. Smith Store on Wisconsin, where the telephone building now stands. In 1926, Hill formed a partnership with E.E. Robinson that lasted 19 years, first in the Beardmore Building, then the Wright Building under the name of People's Market. Hill served in the state legislature's 25th session.

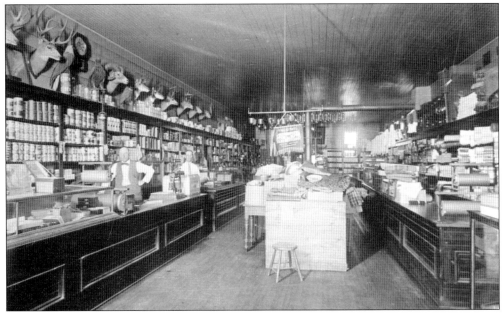

The unique thing about this general store was the mounted heads above the shelving. In the years before 1920, James Stewart was Priest River's taxidermist. According to the Northern Idaho News, the taxidermy shop was located in a new building on Wisconsin Street in 1914. Stewart invented an improved gun sight and left the community for greener pastures soon thereafter. This is a Glenn Stewart photograph.

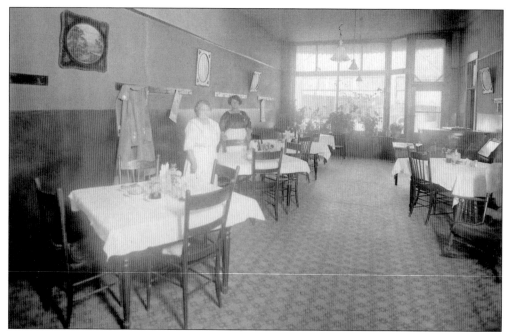

This attractive dining room was in the Hotel Linton on Priest River's Main Street, a building also destroyed by fire after a long life. During its logging boom days, and when everything came into town by train including traveling salesmen, Priest River boasted a number of commercial establishments such as hotels and boardinghouses.

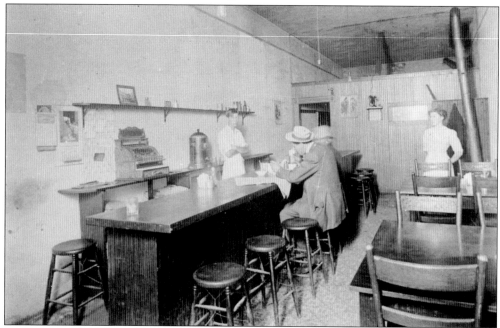

This café in Priest River has not been identified, but the waitress (or cook) backed up to the wood-heating stove demonstrates that the weather outside must have been cold. Glenn Stewart likely took this photograph before 1920. Glenn's son Arley once said he inherited a suitcase full of Stewart's glass negatives in which he could see no value, so he consigned them to the dump.

48

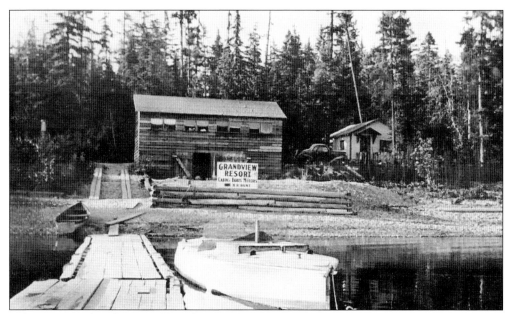

When Vern and Della Howell bought Grandview Resort on Priest Lake in 1949, they expanded it from a small lodge with eight rustic cabins. It changed from serving sportsmen's minimal needs to fulfilling post–World War II vacationers' desires for full-service accommodations and a variety of activities.

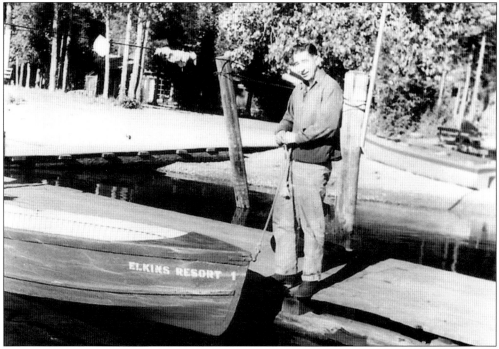

Elkins Resort on Reeder Bay at Priest Lake has undergone many transformations over the years. Originally the homestead of Bert Winslow, it was acquired in 1928 by logger Ike Elkins, who wanted to establish a fishing camp. The Elkins family gradually built new cabins, modernized the old ones, and added a popular full-service restaurant.

George Hill had a far-reaching vision for the old cabins he bought from Earl Farris on the sandy shoreline of Priest Lake's Luby Bay in 1946. He later acquired an adjoining resort from Robert Timms in 1960 and opened a new marina that same year. Today, the family-owned Hill's Resort is a year-round destination featuring deluxe accommodations and fine dining.

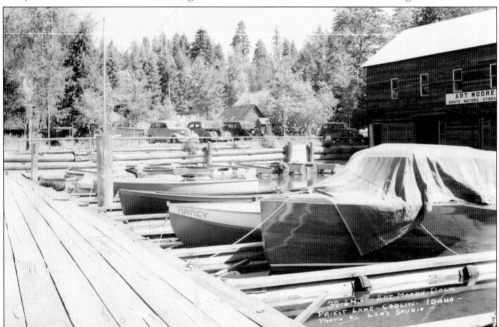

With encouragement from his brother-in-law Leonard Paul, Art Moore purchased the Coolin Marina in 1935 and began to expand the facility and services. When he died in 1952, he left a host of friends and customers who thought Art Moore's Marina was the best boat livery business on Priest Lake.

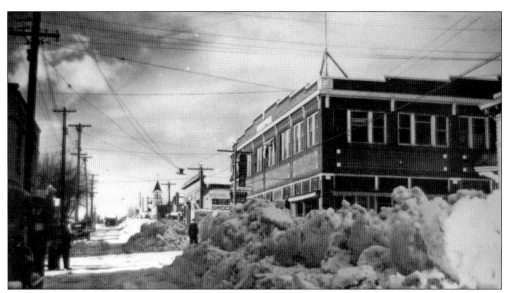

Northern Idaho winters are often snowy, and when the inches accumulate in Priest River, there is no place to move snow except the middle of the street. This c. 1942 photograph shows High Street facing west. The Beardmore Block stands to the right, now a newly restored LEEDS-certified "Gold" building for energy efficiency. Demolished in 1983, the belfry of the old Congregational church is visible beyond.

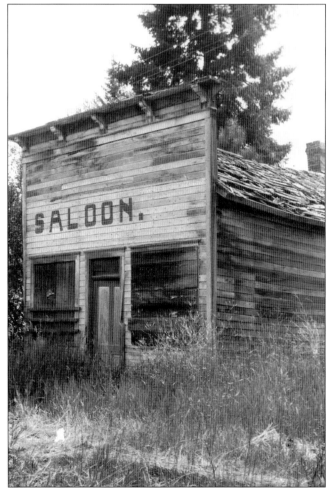

This old frame tavern might have been the first saloon business in Priest River after the town moved from Keyser's Slough. The building was located on the north bank of the Pend Oreille (pronounced *Ponderay*) River, near the Beardmores' St. Elmo Hotel, across the Great Northern Railway tracks from the end of Main Street. It was demolished in the 1950s, as was the hotel.

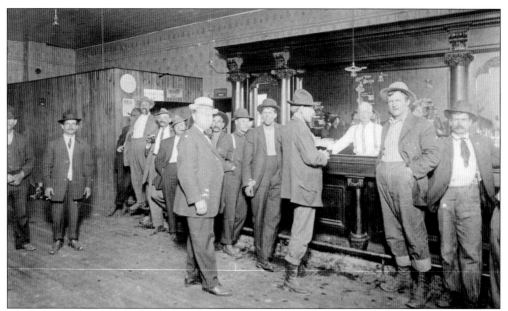

Two c. 1911 photographs by Glenn Stewart show different saloons but some of the same characters. The portly man facing away from both bars is former town marshal Ed Gillaspie. The saloon above is Harvey Wright's. Ed Gillaspie's brother Hugh may be the portly gentleman at the left end of the more plainly furnished tavern. The short man in the suit and hat is Edward Losh. The saloon below is the McIntosh, constructed by the Kramers. In this saloon, the tall man with hat and suspenders is "Old Bill Whetsler," and the short man at the right end is Ed Losh. The little man next to him, in what appears to be a long underwear top or sweater, is Billy Klingball. Homer Redmond stands on the left side in business attire.

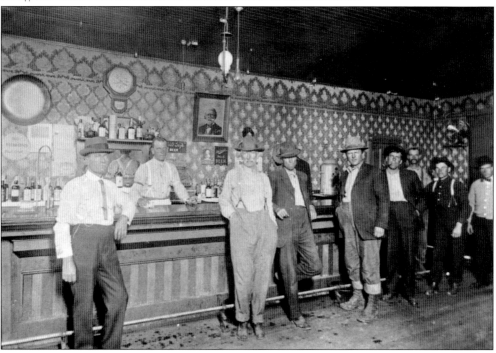

The old Stanley Jones garage building on High Street is shown here as it looked in 1936. The historic Congregational church can be seen in the background. The church was replaced after 1983 with a new building, but the garage, now called the Huot Center after a later owner, still stands and has housed many different businesses over the years. Part of it is now a feed store.

M.O. Booher of the Bungalow, a drinking and dining establishment just west of the town of Priest River, gave a two-year lease in 1941 to a new organization called the Rivercrest Golf Club; thus, the Ranch Club Golf Course was born. The first foursome to play on the formal May 13 opening day were Priest River officials Ralph Yarroll and Robert Gill and their Newport counterparts C.D. McKern and Bert Farrelly.

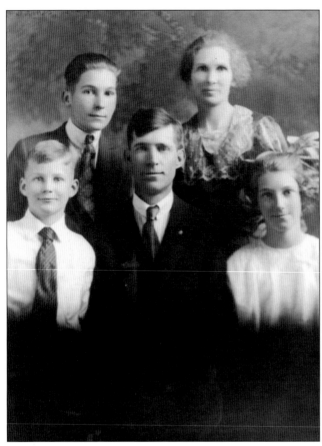

J.G. Parsons published the *Priest River Times* during the era of Nell Shipman, who made silent movies at Priest Lake in the early 1920s. He is shown here surrounded by his family. Clockwise from the left are sons Jerry and Jim, his wife, Hazel, and daughter Evelyn. Jim came home from college when his father died to help his mother manage the business until it could be sold.

The *Priest River Times* was founded in 1914. Its publisher, Kenneth Woods, is shown below operating one of the old linotype machines in what is now Popeye's Bar. The Woods family moved to Priest River from Iowa in 1948 and purchased Priest River's oldest surviving business. Ernest "Pete" Thompson of Pend Oreille Printers in Sandpoint bought the *Priest River Times* in 1976. The Hagadone Corporation of Coeur d'Alene, Idaho, owns it now.

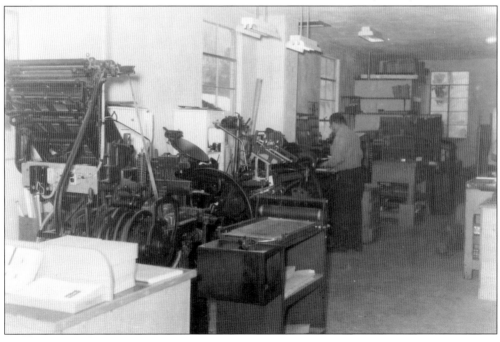

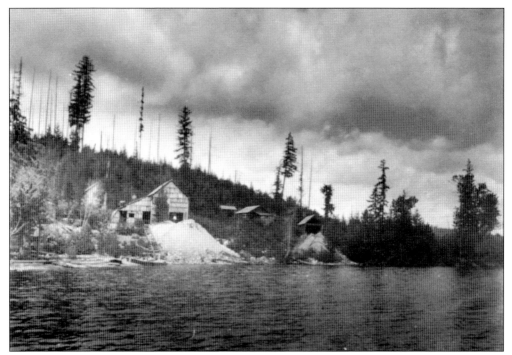

In the late 1800s and early 1900s, there were about 25 small mines around Priest Lake. One of the most extensive was the Woodrat Mine south of Luby Bay. By 1913, the Woodrat had about 300 feet of underground veins that contained lead, zinc, silver, and copper. The property sold in 1922, but indications show that it was never profitable. All that remains today is the waste rock pile and a few pieces of scrap iron.

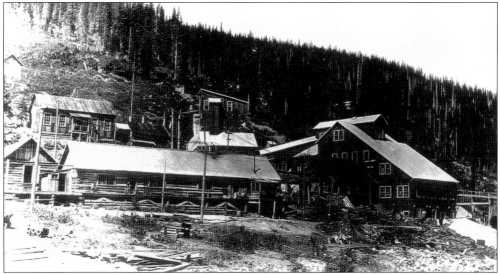

Albert Klockmann was attracted to the Priest Lake area in 1890 by the promise of a rich ore strike. Following a tip, he located the mine on a desolate mountain between Upper Priest Lake and Bonners Ferry. He established the Continental Mine, the area's most successful mining operation. By 1922, the township of Klockmann supported a population of 350 people. The mine closed in 1937 when metal prices fell.

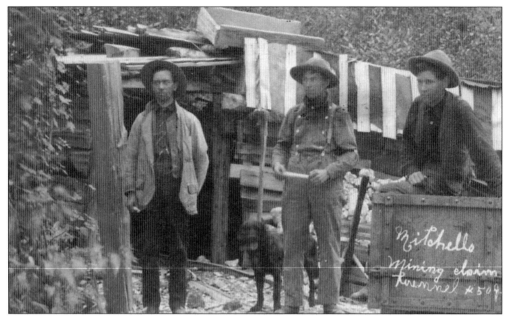

Fueled by claims that Priest Lake was becoming one of the busiest mining camps in the Northwest, hundreds of prospectors flocked to the area in the early 1900s. One miner wrote, "It is a long time since I worked as hard. I have not shaved for six weeks and not cut my hair for two months so I am all the same as a bear." The isolation, the difficult transport of equipment and supplies to remote mountain sites, and the lack of promising ore sent most back home. From left to right are Bill Brawley, Leonard Paul, and Bob Gumaer at Jared Mitchell's mine in 1904.

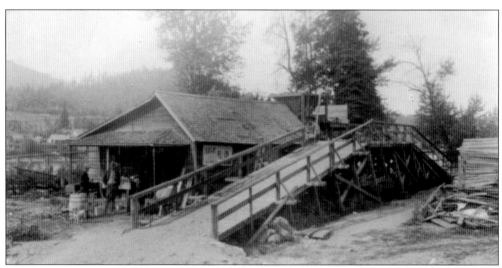

Charles W. Beardmore came as close to a Renaissance man as the town of Priest River ever had. Beardmore had his fingers in many pies, including mining claims at a time when people believed ore bodies north to Priest Lake and beyond might perhaps prove to be as rich as those of the Silver Valley. In 1923, Beardmore built this ore concentrator on the south bank of the Pend Oreille River at Priest River.

Four
FROM TREES TO LUMBER

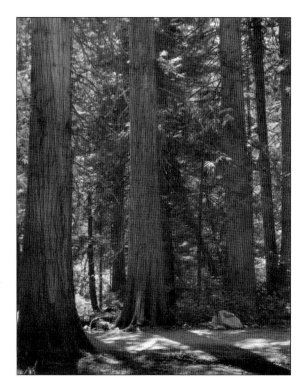

This virgin forest of giant cedars over 800 years old stands 14 miles north of Nordman near Priest Lake. Designated a scenic area in 1943, the Roosevelt Grove, named after Pres. Theodore Roosevelt, provides an awesome backdrop to Granite Falls and Stagger Inn Campground. The upper Priest River area near the Canadian border is considered a temperate-zone rain forest, home to big trees, peat bogs, rare plants, and about 10,000 species of fungi, most of them inedible. It also shelters threatened and endangered wildlife species, such as woodland caribou, grizzly bears, lynx, bull trout, and wolverines.

Calvin Hardesty Huff was the first forest ranger at Priest Lake. A woodsman who came to Kaniksu Country in 1892, he and surveyor Von Cannon mapped the West Side of Priest Lake. Cal and his wife, Sarah, ranched at Blue Lake and built a house that has been beautifully restored in recent years by a member of the Huff family. Community dances held there drew a large attendance.

Benton Ranger Station personnel are shown taking their ease in June 1911 on the porch of what was probably their ranger station, from which the Priest River Experimental Forest would be established in the fall. If the building was the homestead cabin of Thomas Benton, as seems likely, he lost it and his homestead because he had unwittingly filed and built on railroad land. Benton Ranger Station was short lived.

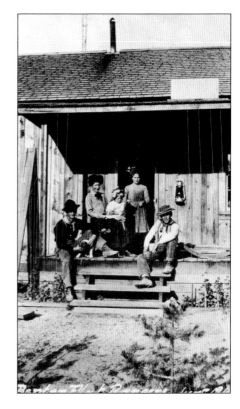

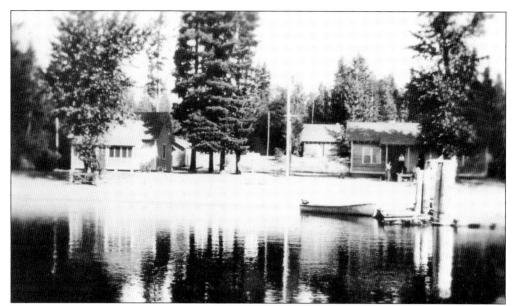

The Beaver Creek Ranger Station, established in 1911 south of the Thorofare on Priest Lake, was pivotal for fire fighting, servicing lookout towers on nearby mountain peaks, and building trails. By the 1930s, the site consisted of a cookhouse, ranger's house, small bathhouse, an office building, and a floating bunkhouse. The Beaver Creek station was consolidated with the Priest Lake district in 1940.

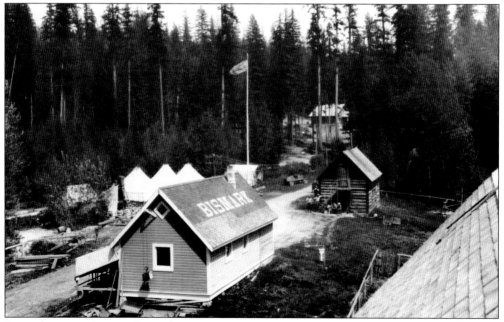

Bismark Ranger Station, located near Nordman on the West Side of Priest Lake, was established in 1927 as a summer base for firefighters and pack trains. Named after an early trapper, the meadow site eventually grew to include log cabins, a cookhouse, warehouse, mule barn, and passable access road. By 1941, the Forest Service consolidated all area ranger stations at Bismark, and it was renamed the Priest Lake Ranger Station.

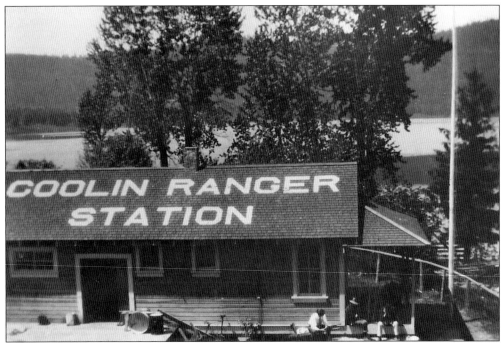

In 1906, a year after Gifford Pinchot created the Forest Service, a ranger station was established at Coolin on Priest Lake to manage and preserve the area's enormous timber resources. The headquarters, built on a hillside next to the Northern Inn, evolved to include a barn, shop, warehouse, office, float houses, boathouses and dock. To fight the fierce forest fires, rangers had only mules and rowboats for transportation.

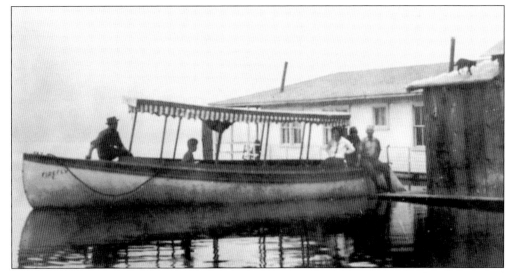

One of the first motorized workboats on Priest Lake was the *Firefly*, a 24-foot launch pointed at both ends. Ranger Ivan Painter recalled it took two hours from Coolin to the Beaver Creek station at the north end of the lake, or three hours if towing a barge. One night in 1912, the barge started to sink in dense fog and had to be cut loose with five horses on board.

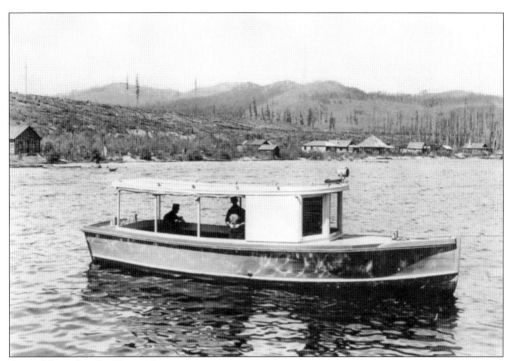

A workboat for the Forest Service on Priest Lake during the 1920s, the *BRC-1* was constructed by Civilian Conservation Corps labor for use by the Blister Rust crews. Each summer armies of young men set up camps around the lake to clear underbrush that supported the Blister Rust fungus. An ungainly boat, the *BRC-1* was scuttled after a few years and replaced with a more efficient craft.

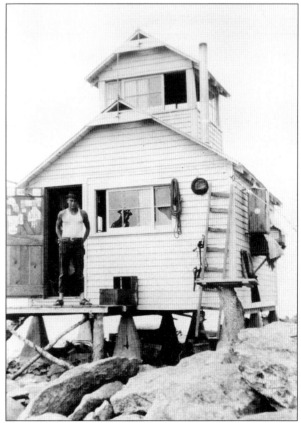

Perched atop Lookout Mountain, this Forest Service tower, built in 1929, still stands today as a historical site. Located at the north end of Priest Lake, the lookout is accessed from Lion Head Campground and offers spectacular views for the experienced hiker. This 1930 photograph shows Rex Stuart of Newport, Washington, in front of the structure. A newer lookout was built in 1977 and is used today during fire season.

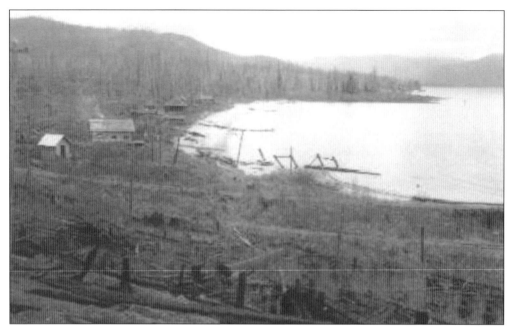

Ghostly snags and smoke were all that remained of Kalispell Bay's lush, green forest after the devastating fire in 1926. A few settlers' cabins miraculously survived the wide-ranging blaze, including one belonging to sawmill owner Fred Schneider. One of the worst fires in Priest Lake history, it was caused by hundreds of lightning strikes in the dry forest. There were no access roads for firefighters or equipment, so it burned for weeks.

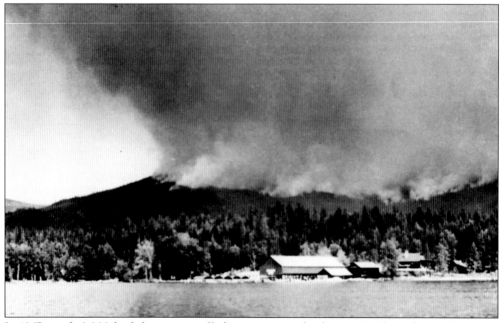

In 1967, nearly 2,000 firefighters were called in to contain the devastating forest fire on Sundance Mountain at the south end of Priest Lake. The wind-powered blaze burned 56,000 acres of prime timberland and came within two miles of Coolin. It was estimated the cost of firefighting and damage to timber, watershed, and recreational property exceeded $16 million.

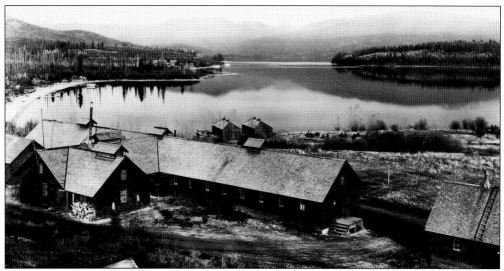

Created in 1933 as part of Roosevelt's New Deal, the Civilian Conservation Corps (CCC) was established to get Americans working again and to protect the nation's natural resources. Corps members, ages 18 to 24, lived in camps and worked on projects in national forests and national parks. Local camps included F-142, located on Kalispell Bay, where the crew helped build roads and trails. A portion of each enrollee's income was sent home to help support his family. The CCC was abolished in 1942.

Located between Priest River and Priest Lake in the Idaho Panhandle National Forest, the Priest River Experimental Forest was established in 1911 as a forestry research center. The site contains ecosystems found throughout the Northern Rocky Mountains and a diversity of vegetation and wildlife, as well as a 15-acre nursery. It led the country in fire research under Harry Gisborne and is open to the public.

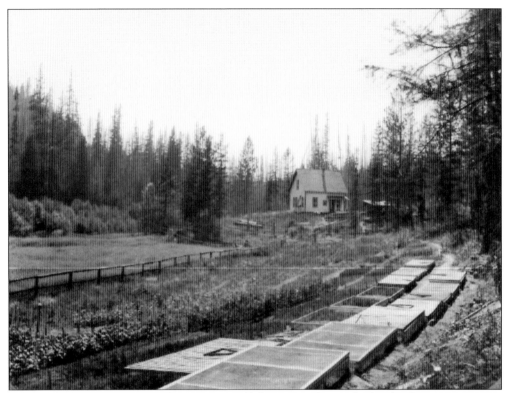

The Priest River Experimental Forest, just off the East Side Road 15 miles from Priest River, celebrated the 100th year of its founding in early October 2011. This 1914 photograph shows conifer seedbeds and rows of hardwoods neatly laid out in the Meadow Nursery, with the original laboratory building in the background.

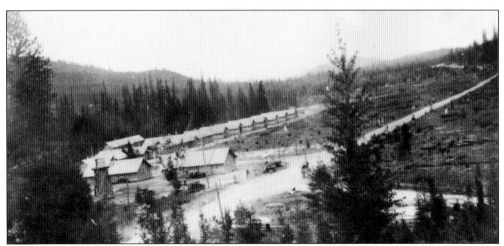

During the Great Depression, the federal government established the CCC under the auspices of the Forest Service as a make-work program for young men and to help out their families. Two CCC camps operated on the Priest River Experimental Forest. This one was F-127.

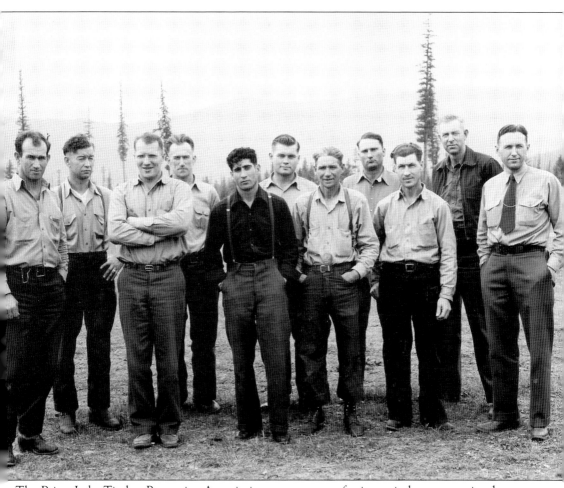

The Priest Lake Timber Protective Association was a group of private timber companies that managed fire protection on the east side of Priest Lake until the organization was dissolved following the destructive 1967 fire season. On May 14, 1944, dignitaries and employees of the association shown from left to right are "Tip" Garrison, Eugene Napier, Clarence Halvorson, Enoch Garrison, John Sudnikovich, Charles Cliff, Ira Stockton, Don Sands, Martin Bennett, John Cluzon, and Leland White. The Idaho Department of Lands at Cavanaugh Bay manages state land on the east side and is now in charge of all fire control.

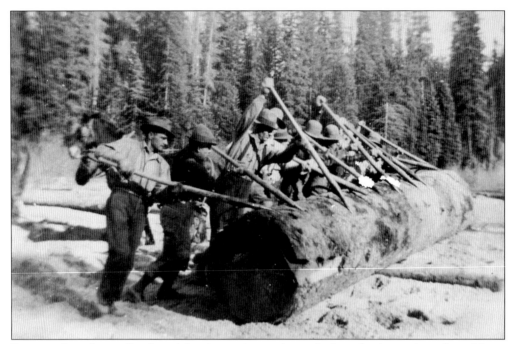

Few people today realize how labor-intensive work was before the invention of machines. Physical labor, especially, was a matter of brawn and numbers. Butt logs from virgin timber, for example, were often discarded in the woods because they were so full of pitch they were too heavy to wrestle with, and they sank in water.

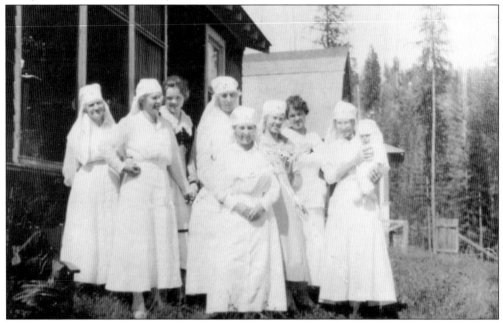

These women attend a Red Cross meeting at the Priest River Experimental Forest station in 1918. The woman not in uniform might be "teacher" Senibe Yokum. The others, in no particular order, are Mrs. Gilbert, Mrs. Kamp, "Mother (Effie) Prater," Mrs. McDonald, Stella Kettelson, and Myra McKinzey, holding baby Louise McDonald, also in uniform.

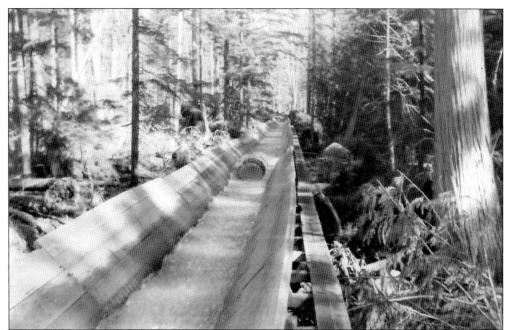

There were no roads in the early 1900s, so harvested trees were moved by wooden flumes that sent logs downhill on a waterslide to the lake. Generally, a dam on a nearby creek provided the water as logs were released into the lake below. The logs were then tied together and towed to the outlet in booms by tugboats such as the *Tyee*.

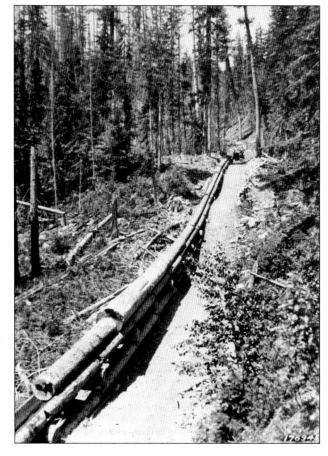

Chutes were a means similar to flumes for moving logs down steep slopes. Flumes moved logs on a bed of water whereas chutes held no water. Horses walked beside the chutes to pull the logs along. To make the work easier, the dry boards of the chutes were lubricated with axle grease and a broomstick or just a plain stick wrapped in a rag.

This handsome young Italian, Victor Jacoy, was killed walking the chute on Gold Cup Mountain while employed on a logging job for A.C. White. He had been sent back to camp to procure some item needed on the job and was on his way back to work when logs were accidentally released on top of him. Albert Jacoy stands on the left of the photograph; Charles Saccomanno is on the right.

Barney Stone is the lumberjack sitting on top of the log deck in the background, and his father, Elmer Stone, is the foreman in the black hat with his back turned to the camera. The camp was located at Prater's Halfway house on the east side in 1913 and was a Victor Pierson job, possibly for Humbird Lumber Company.

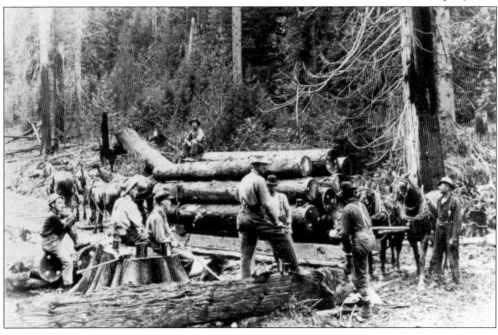

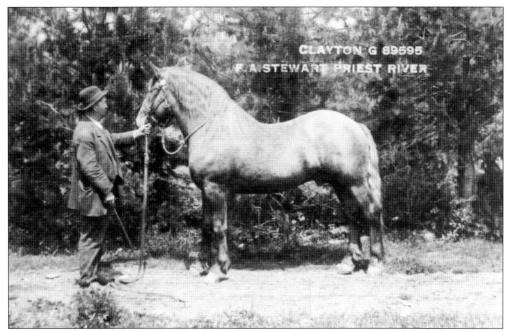

Franklin A. Stewart, who arrived in Priest River in 1891, is shown here around 1907 with his prize stud Clayton G. 89595. The stud was used to breed logging horses and was Frank's pride and joy. The horse eventually had to be destroyed because of thrush. Frank married Nancy E. Koffel and homesteaded on the east side in the Sanborn Creek area. He died in 1927; she died in 1934.

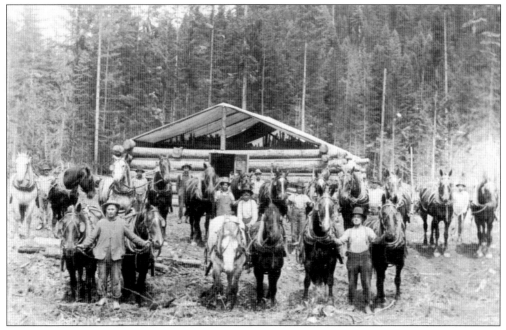

Glenn Stewart took this photograph of C.W. Beardmore's summer barn and a skidding crew in 1913. As all the companies did in those days, Beardmore owned many logging horses and raised massive amounts of hay for them at his Ranch Camp at the Four Corners on the west side between Priest River and Priest Lake.

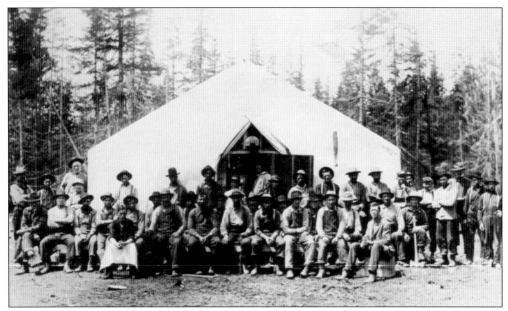

This 1913 photograph by Glenn Stewart shows a logging camp tent kitchen with the crews posed in front. Tent camps were often referred to as "rag camps." The tents could be easily moved along with the job. In 1913, the big logging companies in the area included Dalkena, Humbird, and Beardmore.

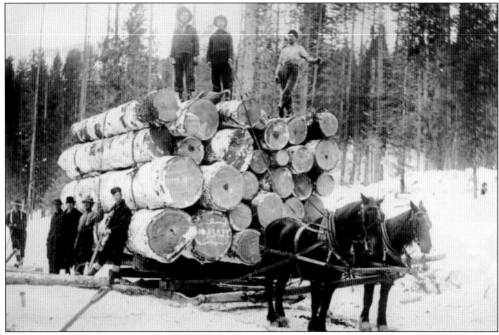

This 1912 photograph by Glenn Stewart shows a loaded logging sled. Until the advent of roads and logging trucks, logging in Kaniksu Country took place primarily in the winter because snow on the ground made it possible for horses to pull heavy loads. The exceptionally large loads sometimes seen in photographs were for "show," not for horses to pull.

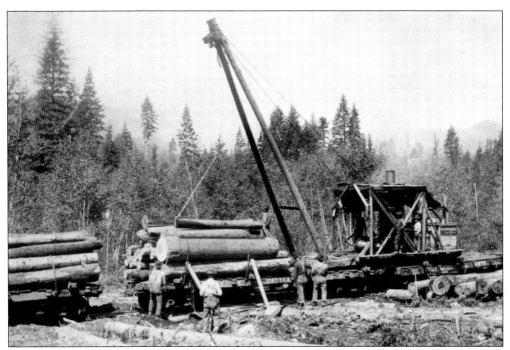

This Glenn Stewart photograph, undoubtedly taken before 1920, shows a steam "slide-ass" jammer loading logs. These jammers were often used to load cedar poles on railroad cars as well. The only name known for them is "slide-ass," so called because they were pulled from car to car on railroad tracks and slid on their bottoms.

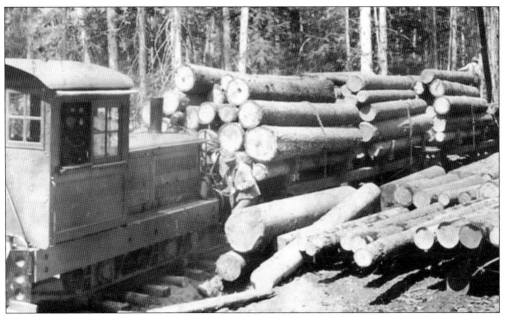

In the 1920s, the Diamond Match Company at Priest Lake operated "Lakeshore Limited" to haul logs from the timber harvest to the landing site at Kalispell Bay. The engine, pulling eight cars loaded with logs, often made the trip twice a day. The knowledgeable hiker can still find remnants of the abandoned railroad.

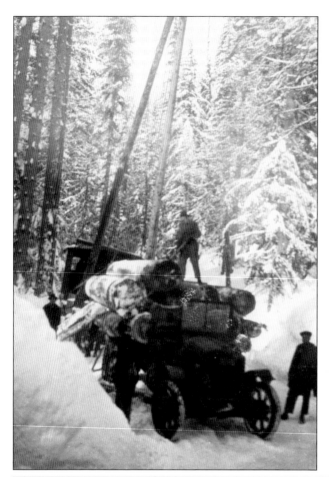

Many different types of jammers have loaded logs in the North Idaho woods. The one shown in the left photograph is an A-frame. Priest River resident and jack-of-all trades Ray Diard invented and built the Idaho Jammer, below, in his machine shop in Priest River, probably some time in the 1950s. Jammers are outdated technology now. They have been replaced by equipment like self-loaders and forwarders. (Idaho Jammer photograph courtesy of Dick Howard.)

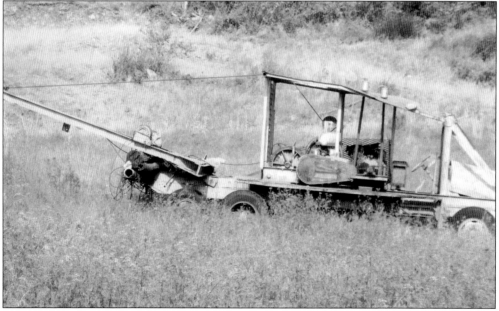

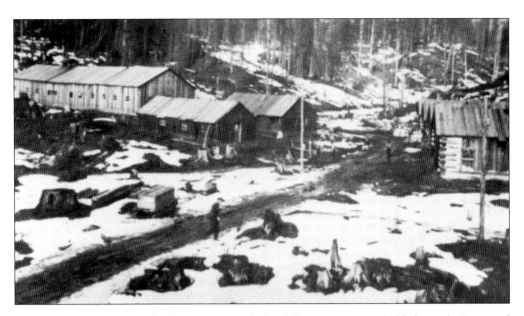

The above 1937 photograph of an Upper Lamb Creek logging camp probably housed a Diamond Match Company crew. Retired logger and "river pig" John Salesky believes "Wood-Em-Up" George Yarno was most likely the crew boss. The bottom photograph shows the Dalkena Lumber Company's Camp 7 on Saddler Creek around 1923. There was nothing fancy about the old-time logging camps. They improved as time went on. C.W. Beardmore's Tunnel Camp was the most infamous. The bunkhouse was a long, low building with no windows and a wood heating stove at one end. There was just enough room for two rows of bunks, and the aisle between the two was barely wide enough to walk between. Imagine the odor when wet wool socks were hung overhead to dry! There were no laundry or bathing facilities available in the early camps.

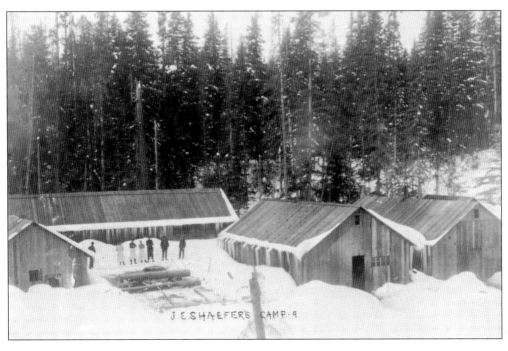

The late Ralph Morrow snapped this photograph of one of the Diamond Match Company crewmembers "at ease" in the bunkhouse. Loggers wore long woolen underwear to keep them warm in wet and cold weather. John Salesky says the photograph was taken at Camp 6, the head of the Indian Creek flume at Priest Lake, and Morrow was the camp mechanic.

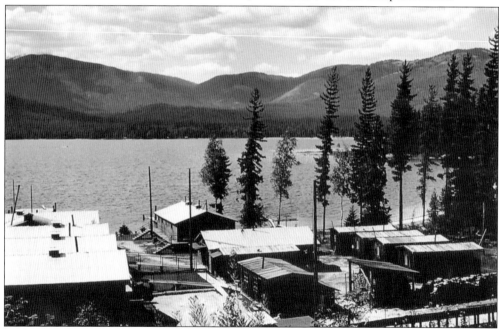

In the 1940s and 1950s, Diamond Match Camp 9 located near Indian Creek on Priest Lake, was one of the most modern logging camps in the area. A showcase facility, it housed over 100 workers in 50-man bunkhouses. This was the camp that hosted many high company and government officials making supervisory trips to the area.

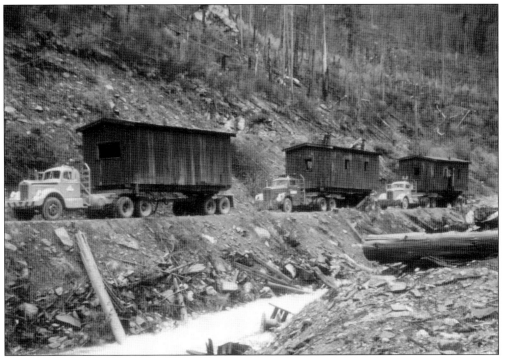

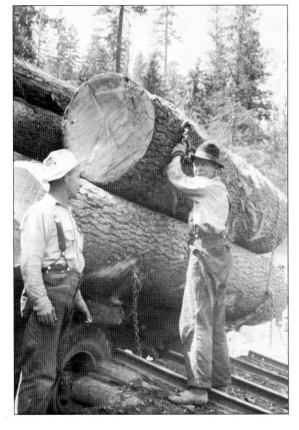

Diamond Match Company built Camp A on East River in 1949 and last used it in 1958. In May 1960, the bunkhouses were moved out of the camp by truck. According to John Salesky, John Schaefer removed the poles from up East River later. In some cases, remains of the area's old logging camps are still visible.

While Kaniksu Country could never grow the mammoth timber the wet Pacific Coast is noted for, its virgin timber was nothing to be ashamed of. These two men have been identified as Marion Boyd (left) and Howard Peterson, binding a nice load at a rail spur or crossing.

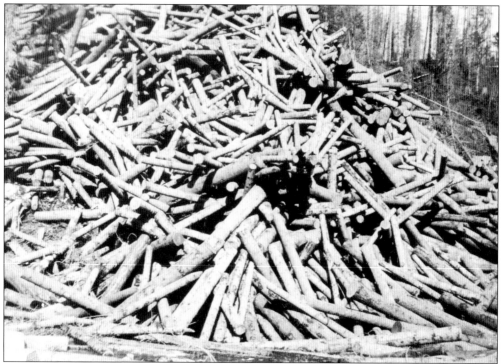

This "jackstraw" deck of logs, holding over two million board feet of lumber, resulted from a Gus Naccarato logging job for Humbird Lumber Company in the winter of 1928–1929. The logs were pulled from the pile into the river by a Fordson tractor during the spring drive. Log drives on the West Branch ended in 1931 when Humbird went out of business.

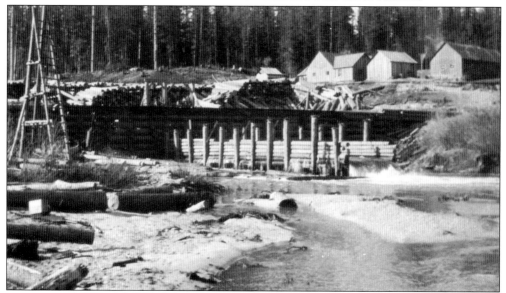

The splash dam at Torelle Falls on the west branch of Priest River was one of many such dams constructed on streams to hold back the water until stream depth was sufficient to float logs. When the cut was ready for release, the dam's gates were opened and the logs sent downstream to the sorting gaps on the Pend Oreille River at Priest River. There, they were directed to the mills.

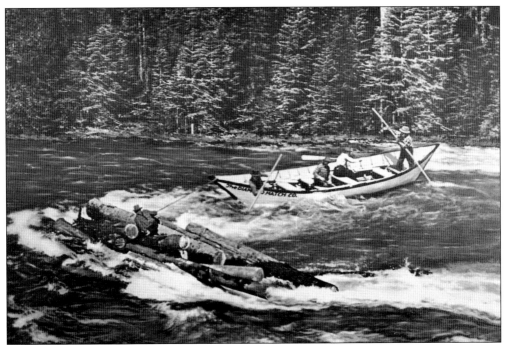

The most dangerous part of driving logs down the Priest River from Priest Lake was breaking up the logjams. An experienced "river pig" would locate the key log, wrench it loose with his sturdy peavey, then leap precariously over the crisscrossed timbers for shore or the security of the bateau, manned by skilled rivermen. The massive log drives down the river ended in 1949.

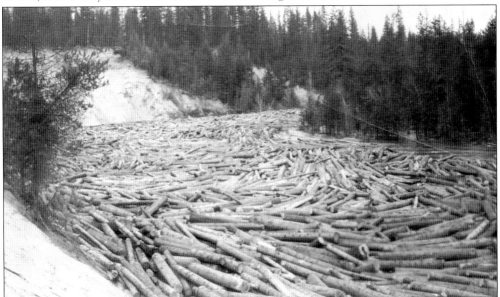

Millions of board feet of logs and cedar poles came down the Priest River in the annual spring drive. They completely blocked the river at times, especially when they reached its confluence with the Pend Oreille River, where they were held for sorting. The log drives widened the Priest River and eroded its banks and landowners' property. The Kaniksu Boom and Navigation Company paid damages in such cases.

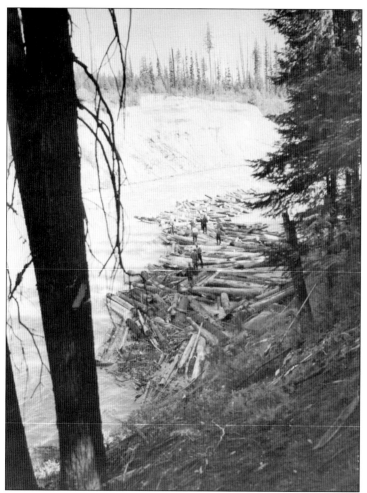

Jams in the river were either wing jams that extended out from shore or center jams that hung up on rocks in the river. This jam on the Priest River was a wing jam. Men called "river pigs" or sometimes just "drivers" broke up the jams by locating the key log. Dynamite was not often used on the Priest River.

A bateau (anglicized from *bateaux*) was a flat-bottom riverboat used in log drives on Priest River. This c. 1920 photograph shows Wallace Doolittle as the second man in the boat facing the camera. Sievert Flaten was the fifth; Henry Lund is standing on shore. A later Diamond Match Company bateau is now displayed at the Priest River Museum.

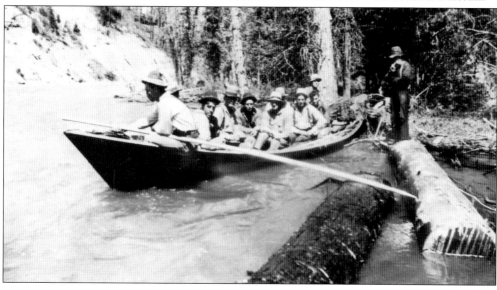

The 1945 or 1946 log drive crew was composed of the following men. Pictured, from left to right, are (first row) Ralph Salesky, Bill McKee, Mart Gumaer, Bill Whetsler, and Joe Gumaer; (second row) John Salesky, Chet Bates, Eldon Gregory, Cliff Damschen, Bill Dodge, George Lohnes, Clarence Pingel, and George A. Naccarato. Naccarato was said to be the only Italian to ever work the drive, for just one year.

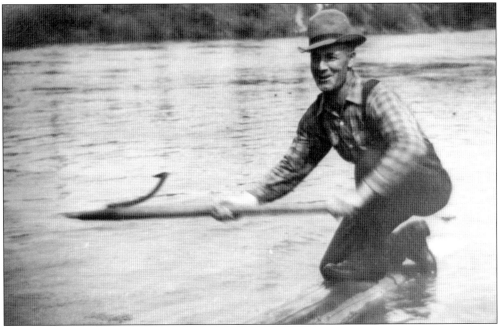

William "Bill" Whetsler was the log drive foreman during the years the Diamond Match Company was in charge. The photograph shows him clowning on a floating log with his peavey, a tool used to turn logs. It is said that Whetsler as "boss of the drive" threatened to "can" any man who fell in the river and failed to come up with his peavey in his hand.

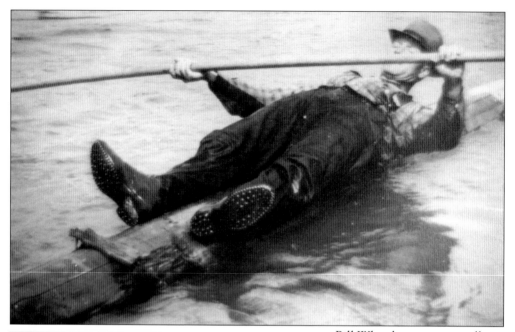

Bill Whetsler was a storyteller and a showman, along with being a superb riverman and logger. This c. 1940 photograph shows him lying prone on a floating log balancing himself with a pike pole held above his body for balance. He even wears a hat, and the caulks on his boots are plainly visible. Bill once appeared on a television show shaving with a double-bitted axe.

Louis Whetsler was a woodsman who did just about everything his brother Bill became noted for, including bossing the log drive. He also was one of the superintendents of the Priest River Experimental Forest. According to some, Bill garnered more recognition because he was a showman and storyteller who courted recognition.

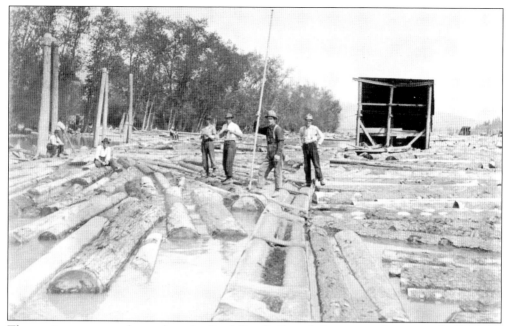

The sorting gaps were located on the Pend Oreille River below its confluence with the Priest River, where yacht club property and a county park are situated today. Logs were branded on their ends to show which mill they were to be directed to and were sorted accordingly after the log drive. If a sawmill received another company's logs, it sawed the logs, wrote down their board feet, and paid the rightful owner.

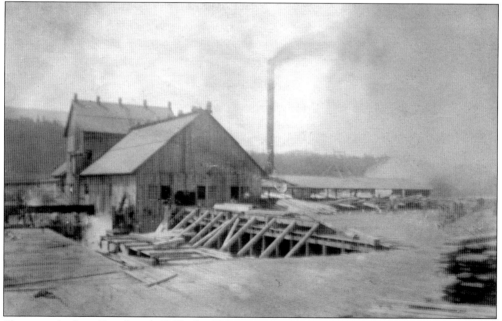

Photographed on October 4, 1903, the White Pine sawmill went up in flames on August 30, 1905, taking the west end of the village of Priest River with it. The facility was situated where Frank Parsons would later build his Parsons' Marina boat business. That commercial endeavor is also gone now.

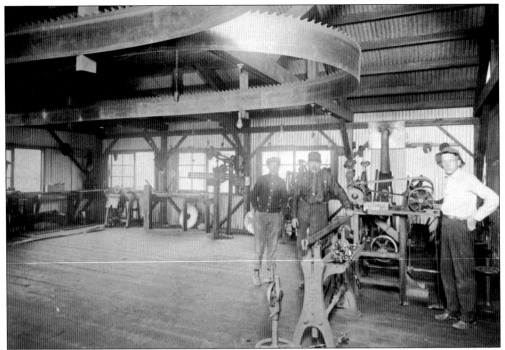

Charles W. Beardmore bought the Jurgens Brothers sawmill in Priest River in 1916, and his Beardmore mill was the mainstay of the town's economy for the next 15 years. This photograph shows the saw-filing room with the long band saws suspended overhead. To keep the mill working, Beardmore operated up to five camps a season in the Priest River drainage and that of the Pack River out of Sandpoint.

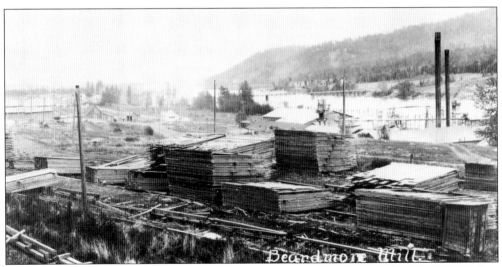

The Beardmore plant was located along the Pend Oreille River, below the Priest River City Park. The mill ran two shifts a day when the lumber market was profitable and was the town's largest employer. The depression that began in 1929 spelled the mill's doom.

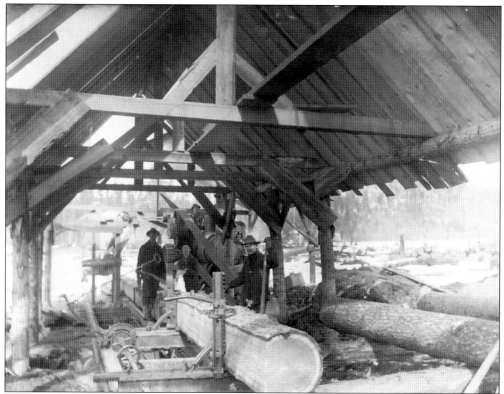

This small sawmill was located on the William Shaw property that he called Alderbrook Farm, located about 3.5 miles north of the Pend Oreille River on East Side Road. Frank Henkle operated the mill, almost alongside Fred Shaw's house just down the hill. The two brothers came to Priest River in 1891 and settled on adjoining land. Fred sold his property to Will in 1909 and moved to Virginia.

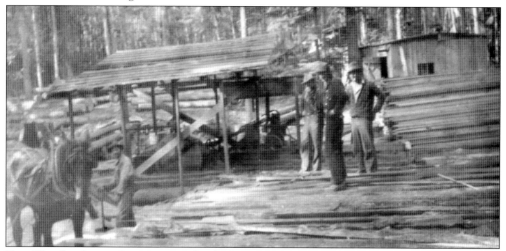

Four Wear brothers—Converse, Hugh, Thomas, and Clyde—and their father, Clymer, established this small sawmill in the late 1930s at Keyser's Slough at Priest River and sold it in 1941 before the outbreak of World War II. Hedlund Lumber Company, Georgia Pacific, and Louisiana-Pacific were subsequent owners. The site is now a wetlands bank.

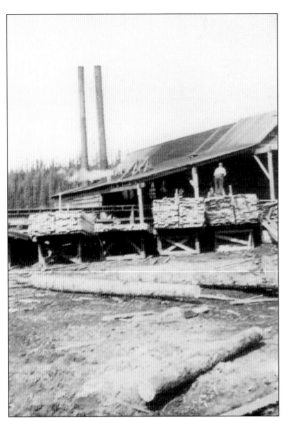

John "Jack" Fuher's little sawmill, known as the East River Lumber Company, was located up East River in 1945. Jack's wife, Rogene, also worked in the sawmill. When it burned, it was relocated to Bodie Canyon at Priest River. It became the Nelson Lumber Company, then JD Lumber, and went out of business in 2007.

E.C. Olson, affiliated with the Diamond Match Company, operated this small sawmill at the Four Corners north of Priest River. The photograph was taken around 1947. Olson established a lumberyard on Main Street in Priest River about 1950. That site then housed the Kaniksu Medical Clinic, followed by the Priest River Medical Clinic, and is now the Priest River branch of the West Bonner Library.

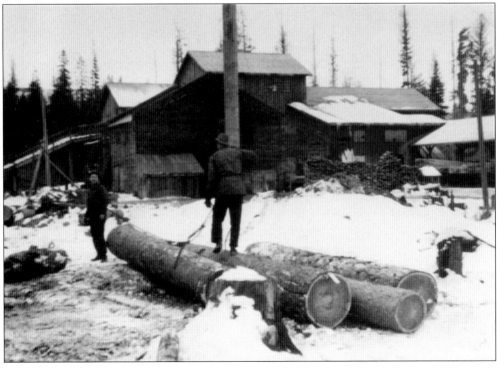

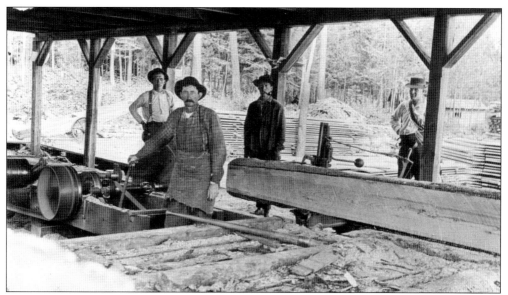

Art Marston's small sawmill across the bay from Coolin provided milled lumber for Priest Lake's frame houses and barns in the early 1900s. He had a steam-powered head saw, an edger, and a trimmer but owned no planer at first, so the boards were rough-cut and often varied in thickness. Local lore tells that the mill's sawdust pile was a hiding place for illegal moonshine during Prohibition.

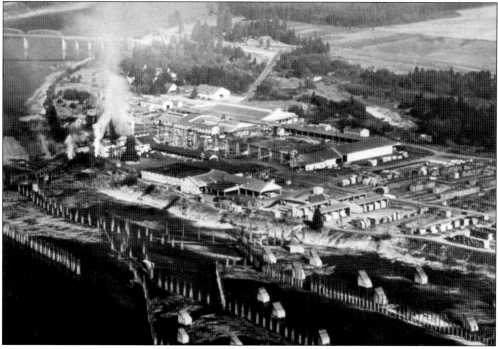

Ralph Salesky took this aerial photograph of the Diamond National plant at Albeni Falls on the Pend Oreille River on September 5, 1958. It was the largest lumber concern in the area and the only unionized plant, until what was then Diamond International was taken over by a British financier in a hostile takeover in the 1980s. The site is now a remanufacturing plant known as Tri-Pro Cedar Products.

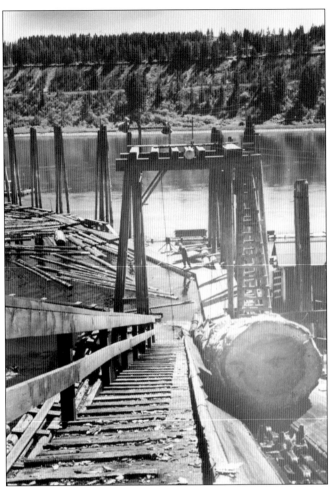

This photograph shows the bull chain on the river slip at the Diamond Match Company plant at Albeni Falls moving a log out of the Pend Oreille River into the sawmill around 1960. After World War II, Diamond Match matured into a highly diversified multinational enterprise variously known as Diamond Gardner, Diamond National, and Diamond International. The company evolved from the consolidation of 12 match companies in 1881.

Brothers Wayne and Wilbur "Buck" Merritt purchased this stud mill on the Pend Oreille River at Priest River in 1967 and made it one of the most successful lumber businesses in northern Idaho. M.J. "Dutch" Shields and William Shields established the mill in 1960 across from the bridge, later named for the Merritts. They sold it in 1993 to Idaho Forest Industries. It now operates as Stimson Lumber Company.

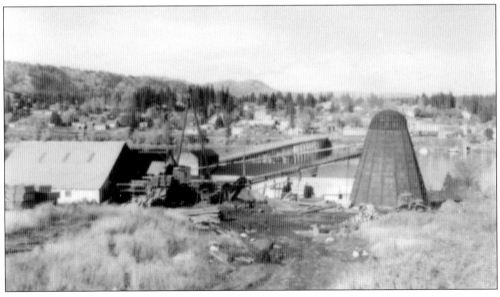

John Schaefer owned the Kaniksu Cedar Company in Priest River in 1930. He entered into a partnership with Beecher Hitchcock of Sandpoint, and the business became Schaefer-Hitchcock. By the mid-1940s, the name was Joslyn Pole Company. According to a 1930 calendar caption, Kaniksu Cedar was shipping 300 to 500 carloads of cedar poles per year.

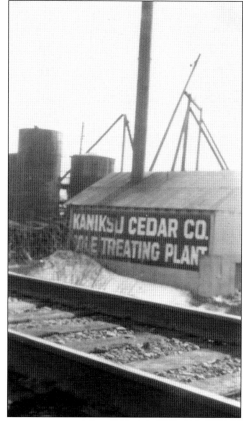

Charles Perin drove this load of poles out of Squaw Valley at Priest Lake in 1936 on a truck belonging to Stanley Jones, who also owned a garage in Priest River. Perin's brother Ed is seated on the longest pole sticking out over the cab. Poles like these made North Idaho "the cedar pole capital of the world."

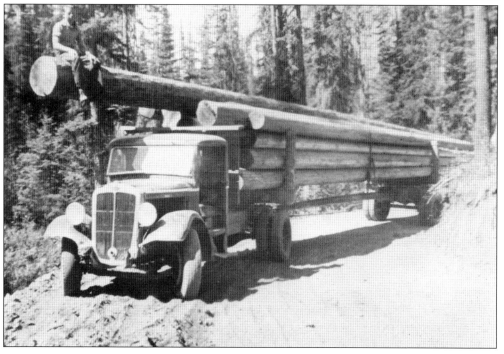

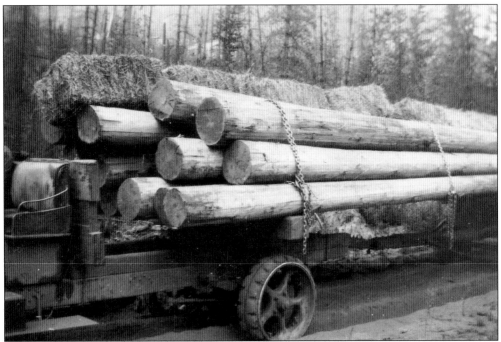

This hard rubber–tired truck probably belonged to one of the Petersons in the 1920s, possibly Howard, who hauled poles, logs, and lumber for various companies. It was the practice for truckers to pick up hay where available and deliver it to camp for the horses. The Petersons are said to have once hauled a pole that was 120 feet long.

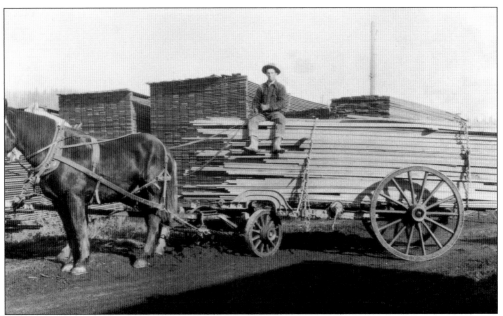

Clarence Painter sits on this load of lumber at the Humbird Lumber Company mill at Albeni Falls around 1920. Fidelity was the first mill at the site, followed by Humbird, then Diamond in its four manifestations, DAW Forest Products, and Crown Pacific. All are gone now.

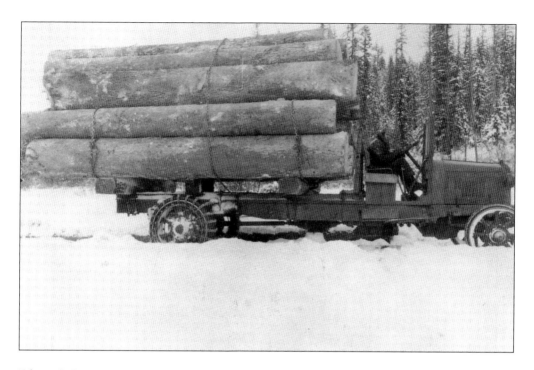

Edwin G. Peterson was engaged in hauling logs for the Humbird Lumber Company on Gleason Meadows Cutoff Road between Priest River and Priest Lake in the winter of 1928–1929. Notice the hard rubber tires on this Federal Motor truck and the open-air cab. In the c. 1919 photograph below, it appears to be the same truck but is shown hauling lumber. In both photographs, Peterson is in the driver's seat of the truck. In his later years, he operated the Diamond Match mill's "Big Wheel" until 1966, which now sits at the end of Washington Street in Newport. He came to Priest River from Wisconsin and married Ethel Brumley. Ethel came to Priest River from Missouri as a child and remembered trees here so tall "they reached to heaven."

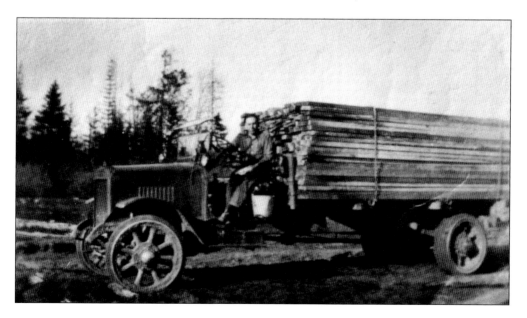

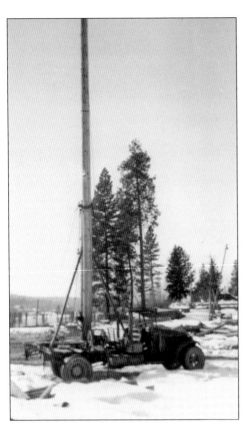

Photographed by Ralph Morrow, this outfit is believed to be part of a "highline" or "high lead" setup that was used to transport logs out of an inaccessible area where they could not otherwise be feasibly reached, such as a forested mountainside over a canyon.

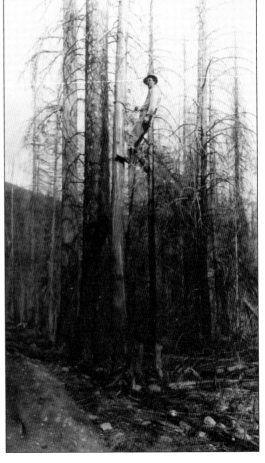

This fellow is preparing to "top" a tree. The practice is still used by landscapers and tree pruners as a treatment for hazard trees that might fall where they could cause damage or that might break and fall in the process of being felled. Such trees always posed a danger to a sawyer or hooker.

Five

ON THE ROAD TO PROGRESS

The only access to Priest Lake in the 1890s was a trail blazed by Indians and trappers. By the early 1900s, the trail became a primitive road full of stumps, chuck holes, and deep dust in summer, requiring an all-day ride from Priest River. The stage would stop at Prater's Halfway House near Blue Lake at noon for lunch and arrive in Coolin in late afternoon. Travel was even more uncertain in winter because rain turned the dust to mud, and snow might block the road altogether. Bonner County spent $3,000 rebuilding the road in 1910, and the auto stage replaced the horse stage in 1914. But the East Side Road was still a trial to travel at times even into the 1950s. Today, State Highway 57 provides an easy 30-minute journey from Priest River to Priest Lake.

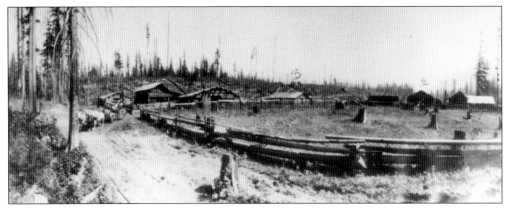

This 1909 view of the Prater Halfway House shows the horse corral and a Beardmore stagecoach leaving the rest station. Because of the frightful road conditions, horse stages were pulled by two yoked teams. Originally, horse stages crossed the Priest River just above its confluence with the Pend Oreille River via a large sandbar that eventually washed out. Later, the "Old Red Bridge" was constructed at the end of Larch Street.

This c. 1920 photograph shows Willard Peterson standing between a team of horses noted for "running away at the drop of a hat." The team carried the mail for Jess Johnson from Priest River to Nordman, a distance of 40 miles or more.

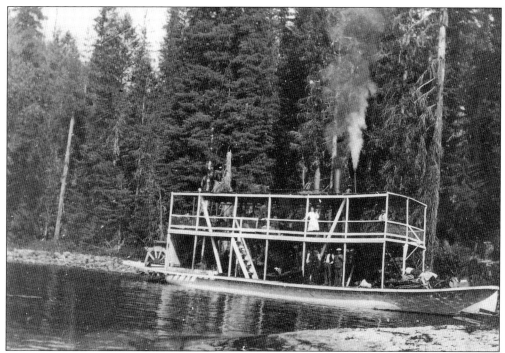

After Cecil Wheatley patented his 160-acre homestead on Upper Priest Lake, he platted it as the town site of Wheatley in 1905. Promising a "profitable investment" in a fisherman's paradise, he said that "behind each rock lies a hungry fish." To bring prospective buyers and supplies to the remote site, he built the *Banshee*, a 60-foot paddle wheeler that was scuttled after it hit a submerged rock on its maiden voyage.

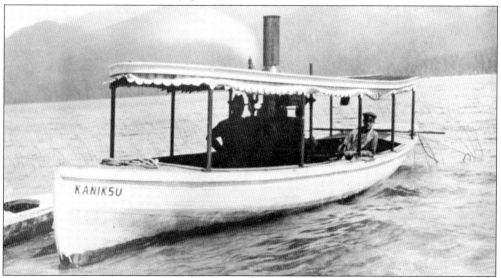

Recognizing the need for boat service on Priest Lake, Spokane businessman J.B. Slee formed the Priest Lake Navigation Company in 1896. He brought the steamboat *Kaniksu* on a lumber wagon from Priest River and began regular trips around the lake, taking supplies and passengers to isolated campsites. After 1900, Slee built a larger steamer, the *W.W. Slee*, designed to enable his polio-stricken son, Walter, to pilot it from a chair.

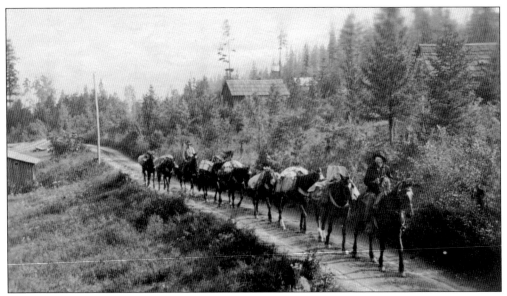

From 1907 to 1933, pack trains from the Coolin Ranger Station serviced lookouts and trail crews around Priest Lake. Mules could carry a 160- to 174-pound load of supplies, which might include lumber, cast iron stoves, firefighting equipment, and even eggs. A skilled packer was careful to balance the load so the mules could navigate the narrow mountain trails.

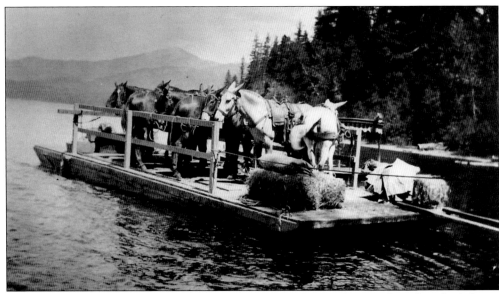

Kaniksu, a real workhorse for the Forest Service, was used to tow barges of supplies, firefighters, and pack strings to points on the East Side and Upper Lake. The boat had been confiscated from rumrunners in Puget Sound and made available to the Forest Service, which operated it until 1950.

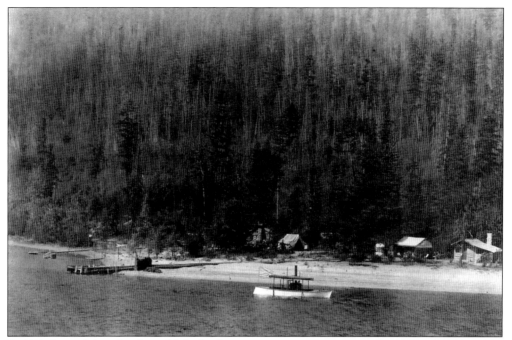

By 1911, farmer Mose Smith established a thriving camp near West Twin Island on Priest Lake under a long-term lease with the Forest Service. His steamer *Sacajawea* brought supplies and passengers 25 miles up lake from Coolin, as there were no roads into the area until many years later.

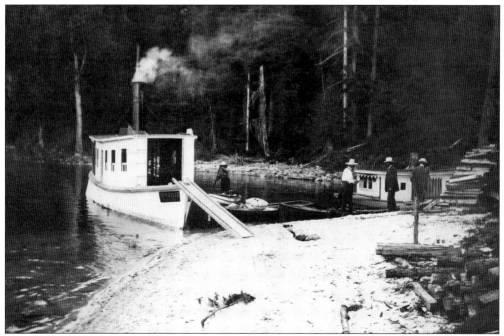

The steamboat *W.W. Slee* provided much needed service to Priest Lake's growing population in the early 1900s. Built by Spokane businessman J.G. Slee to transport passengers, goods, and mail, the boat ran from April through November, piloted by Walter Slee. After Slee's death in the 1920s, his fireman Bert Winslow operated the boat until the 1930s.

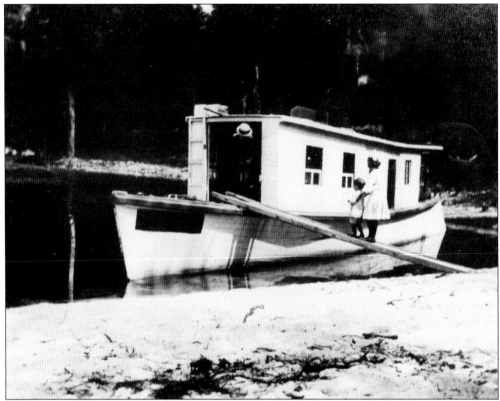

J.G. Slee's granddaughter Harriet Klein Allen said of the steamer, "It carried passengers and firefighters and whatever else was needed from Coolin to the head of the lake every day. We'd be back by 4:30, unloading those we'd picked up, mail to go out, and lists for Leonard Paul to fill." This 1912 photograph shows Harriet and her brother Ned going up the gangplank.

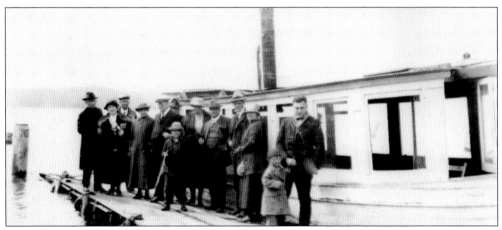

This group gathered on the dock at Coolin to board the W.W. Slee for a trip to attend Nell Shipman's picnic at Mosquito Bay in 1923. Identified on the left are Charles and Lucy Beardmore of Priest River with Leonard Paul and daughter Marjorie on the right. To transport the large crowd, a barge was secured between two steamboats, and the merrymakers enjoyed the scenic cruise to Lionhead Lodge.

Sam Byars came to Priest Lake as a young man from Tennessee and filed for a homestead along Lion Creek near the mouth of the Thorofare. Byars developed a profitable business with Forest Lodge, one of the few resorts on the lake in 1914. He is shown with his launch *Papoose*, which ferried guests from Coolin up lake to the hotel.

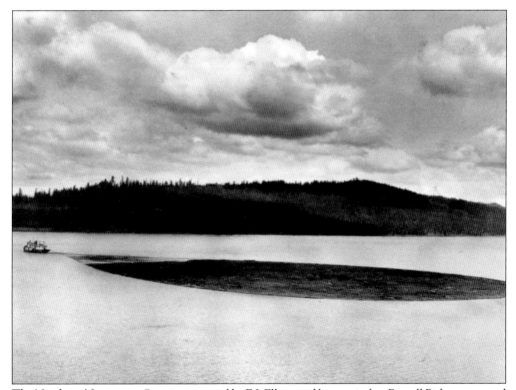

The Northern Navigation Company, owned by E.J. Elliott and his son-in-law Russell Bishop, operated the *Tyee* and *Ridley* on Priest Lake in the 1940s, towing logs for the Diamond Match Company. The *Ridley* cut out booms from the logs, which were held close to shore near logging operations. The larger *Tyee* towed the booms down lake, a trip that sometimes took up to 60 hours.

As a youth, Melvin C. "Cap" Markham operated boats on the Pend Oreille River and later moved to Priest Lake, where he continued his boat business. Tall and bearded, he was known for his trademark buckskins and pipe. Markham attracted curious crowds as he built the steamer *Tyee II* on the beach at Coolin in 1944. The boat was later scuttled at Mosquito Bay and can be seen today mired in the shallow water. The second photograph shows one of Cap's boats, the *Seneacquoteen,* at Beaver Creek Ranger Station on Priest Lake on October 11, 1933. Cap's buckskins are displayed today at the Bonner County Historical Museum in Sandpoint. His was the first white family at Seneacquoteen, across the Pend Oreille River from Laclede.

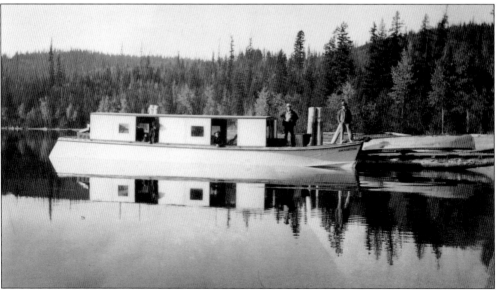

Pearl Thomas Peach was the Great Northern Railway depot agent in Priest River for almost 30 years. He continued to live in Priest River after he transferred to the Newport Depot, because his wife, Jessie, refused to move. He was known as "Peach" because he was so sensitive about his first name. The Peach home is now the Priest Gardens business on Treat Street and Highway 2.

In 1913, a dignitary came to Priest River on the train, judging from the size of the crowd and the presence of the town band in this Glenn Stewart photograph. It could not have been Queen Marie of Romania, however, as she once slipped through town in the dead of night at a later date.

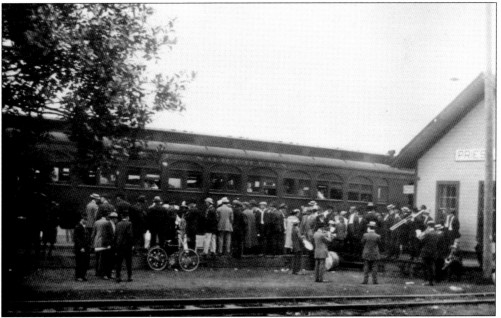

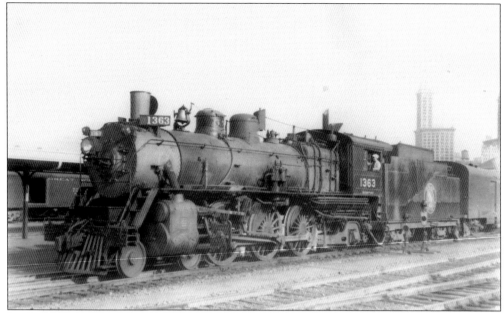

In the photograph above, engine No. 1363 was identical to No. 1012, the engine that went into the Pend Oreille River at Thama on January 13, 1911, when the coupling broke between it and lead engine No. 1447. Excessive speed was the cause. The engineer and fireman on No. 1012 died, and only engineer Zumwalt's body was recovered when the Great Northern Railway raised the engine in March 1913, and put it back in service.

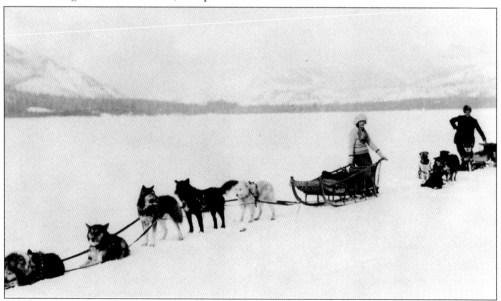

Nell Shipman's prized malamutes appeared in outdoor adventure movies filmed at Priest Lake in the 1920s. The dogs played in a real-life drama when Shipman's partner Bert Van Tuyle needed emergency medical care in the winter of 1924. After a perilous journey down lake, Van Tuyle became delirious and the dogsled stalled in deep snow. Joe and Fred Gumaer of Priest River rescued them, and Van Tuyle recovered at a Spokane hospital. (Photograph courtesy of the Museum of Arts and Culture, Spokane, Washington.)

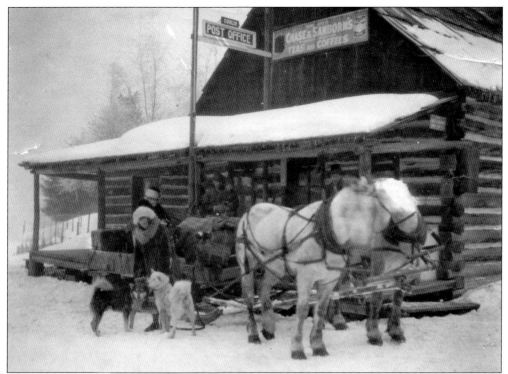

Before automobiles and snowmobiles, Priest Lake's residents turned to sleighs, dogsleds, snowshoes, or skates for winter transportation. Weather permitting, Nell Shipman, shown here, made regular trips from her Mosquito Bay compound with horses and sleigh or dogsled to pick up supplies for her film crew and zoo animals at the Leonard Paul Store in Coolin, a round tip of nearly 50 miles.

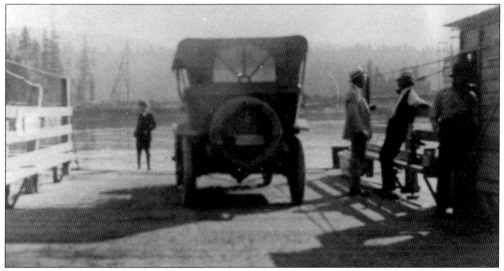

William Vane of Newport, Idaho, has been called "one of Idaho's most intriguing legends." He may be the gentleman leaning against the Newport Ferry railing, near his car, in this photograph. A wealthy and influential citizen, Vane was the mastermind behind the Beardmore Stage holdup at Priest River in 1914. He committed suicide in 1919 in a jail in Newport, Washington, but some people thought he was murdered.

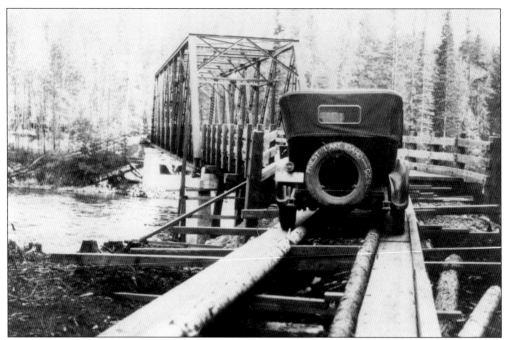

The Dickensheet Bridge spanning the Priest River was the last link in a road system that connected Coolin to the West Side of Priest Lake. Built in 1925, the bridge was named for a pioneer rancher. It was a five-hour journey by motorcar from Spokane on a good day, but travelers were often mired in mud during the spring thaw or stalled in winter's deep snow.

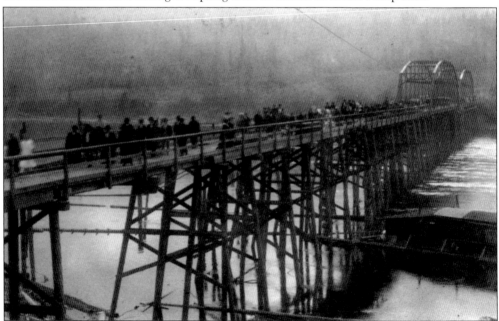

A great crowd gathered on the Pend Oreille River Bridge at Priest River in 1916 when the bridge replaced the ferry, shown tied up in the water below. The event occasioned a great celebration, since ferries were an inconvenient and not always a safe method of crossing a stream. Having the most surface water of any county in Idaho, Bonner County had many ferries.

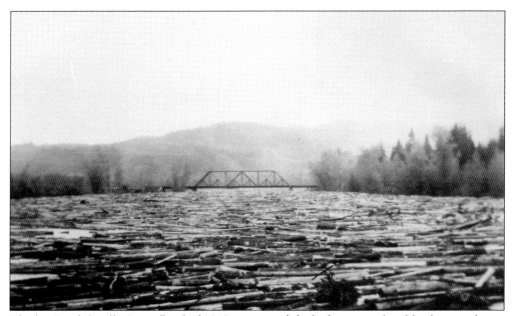

The big Pend Oreille River flood of 1948 put a good deal of stress on local bridges, as shown in this photograph of the bridge over Priest River. In 1894, flooding prompted the move of the fledgling settlement near the Pend Oreille River's confluence with the Priest River to higher ground to the west. Now, Albeni Falls Dam downstream prevents such severe flooding.

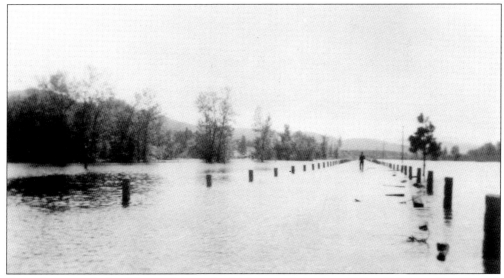

A gentleman with the dubious claim to be fishing stands in the middle of Highway 2 at Keyser's Slough during the Pend Oreille River flood of 1948. Construction of Cabinet Gorge Dam on the Clark Fork River and Albeni Falls Dam on the Pend Oreille River ended such extreme flooding.

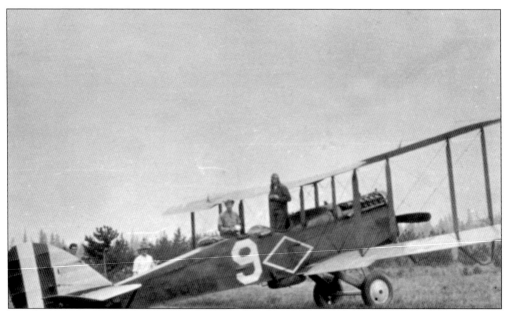

Not many people know Priest River had the first airfield in Bonner County, aided by the Dalkena Lumber Company in 1928. The field was dedicated in 1931 but was not recognized as an airport by the Federal Aviation Administration until after World War II. The airplane pictured here was a Curtiss-Wright Jenny, sold to the public after World War I; it was often used to haul mail.

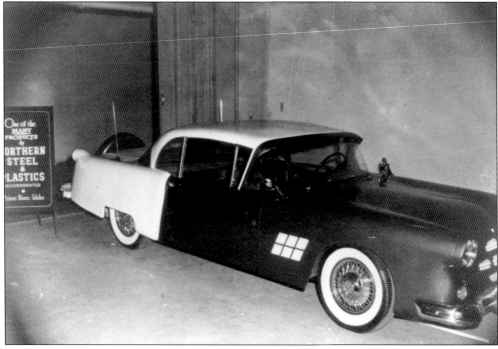

Ray Diard owned a machine shop in Priest River, located in the Quonset hut that still stands behind a restaurant and across from Cottonwood Village at the bottom of Murray Hill. In the early 1950s, Diard designed and built this steel and fiberglass car on a Ford chassis, with a crew that included Michael Edgar, Clark Foss, Clark Howard, and Jack Zimmer.

Six
Year-Round Playground

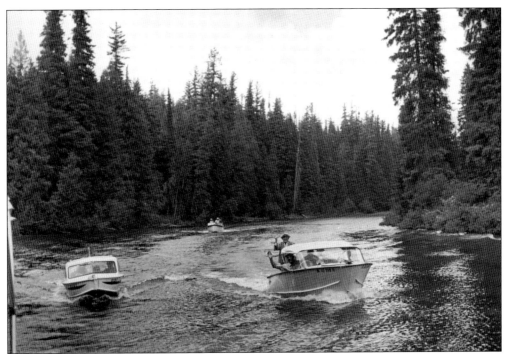

The Thorofare connects Priest Lake to the primitive wilderness area of the Upper Priest Lake. The waterway is a scenic two-mile passage for kayaks, canoes, and slow-moving motorboats. Now a favorite excursion for residents and tourists, the Thorofare was once home to early-day sourdoughs who built log cabins along the banks and eked out a living by trapping, mining, and bootlegging. (Photograph courtesy of Ross Hall Studio.)

This community picnic took place at the Edward "Ted" Hamshar place on the Sanborn Creek Road near Priest River. Hamshar stands in front of the tree. Two over from the tree in hats are Paul Finstad and William Shaw, "Grandma" Long, Helene Herr in a white blouse and dark skirt, and Bertha Shaw in the white dress. The others are unidentified.

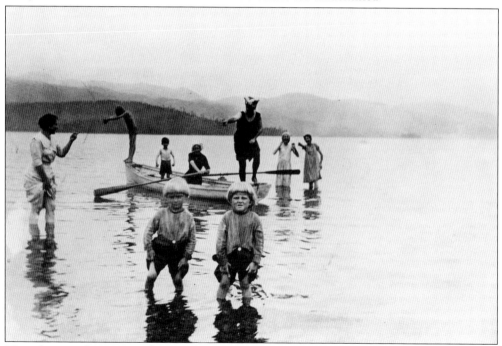

This photograph captures the Winslow family at play in the clear, cool water of Luby Bay in 1915. Swimsuits of that era were made of wool and tended to be itchy and heavy when wet, so many preferred to wear their regular clothing to Priest Lake's beaches.

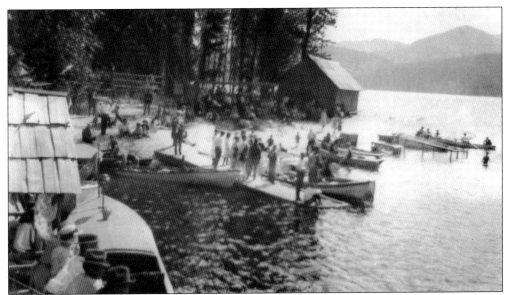

In 1923, silent-screen star Nell Shipman invited Priest River and Priest Lake residents to a picnic and open house at Lionhead Lodge on Mosquito Bay. More than 300 merrymakers attended, many traveling on a barge towed between two steamers from Coolin. They were treated to a day of games, contests, band music, and the wild animal zoo.

Nell Shipman and Jesse Parsons, editor of the *Priest River Times*, greet throngs of visitors to Lionhead Lodge on Priest Lake in 1923. Shipman maintained an extensive wild animal zoo plus film crew and equipment to produce outdoor films at the lake but abandoned the ambitious project after her money ran out in 1925. She did complete several films first, however.

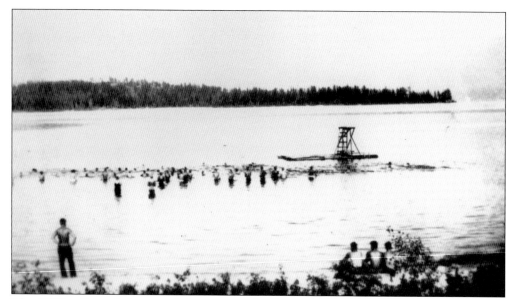

The CCC at Priest Lake provided manpower for Forest Service projects from 1933 to 1942. It brought young, inner-city youth from eastern states and housed them in one of seven camps in the Priest Lake area. Taking a break from constructing roads, trails, lookouts, campgrounds, and station buildings, these men are learning to swim at Kalispell Bay.

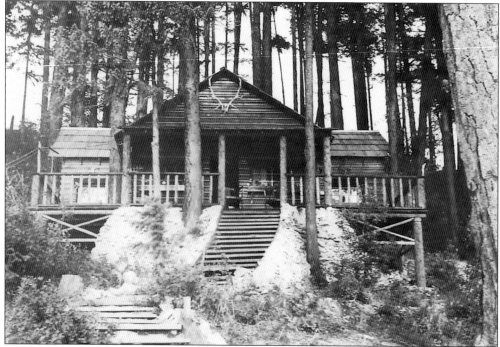

This cabin on Priest Lake's Four Mile Island was a vacation getaway for the Sanderson Family in the 1930s. The island, located about four miles from the south end of the lake, was once a cache site for the Kalispel Indians, who stored their lodge poles and tule mats until they returned for hunting and fishing in the fall. Today, the Idaho Panhandle National Forest maintains its single campsite.

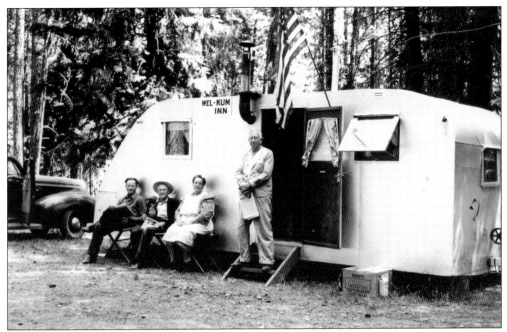

The Luby Bay Campground at Priest Lake was established in 1928 by the Forest Service and was expanded during the 1930s by the CCC. This photograph shows the trailer of the grounds attendant in 1945. Today, the popular campground has 52 sites in two sections, Upper Luby and Lower Luby, and is accessible to a sandy beach and boat ramp.

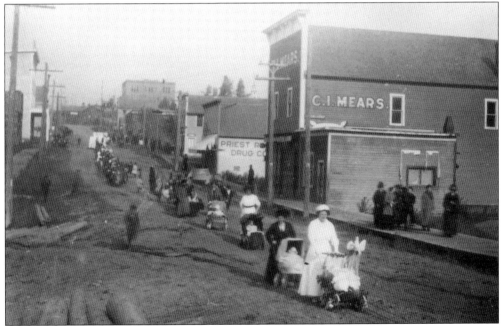

Priest River was so happy to be rid of the ferry across the Pend Oreille River that it threw a party to celebrate the opening of the first bridge in 1916. One of the features was a parade including a contingent of baby buggies, shown here on Wisconsin Street. The old brick school can be seen in the background.

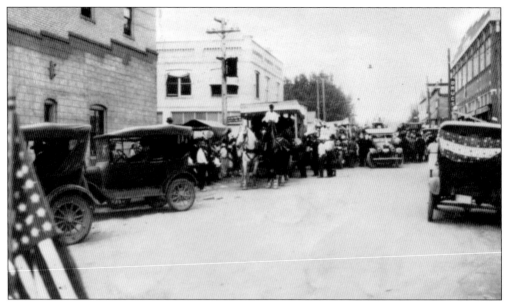

This photograph of a Fourth of July celebration is erroneously dated 1922. The photograph could not have been taken before 1923, since the Beardmore Block, which opened in late 1922, is shown on the right. The street is High Street in Priest River, at its intersection with Main Street. Both the Beardmore and the tall building directly across from it still stand.

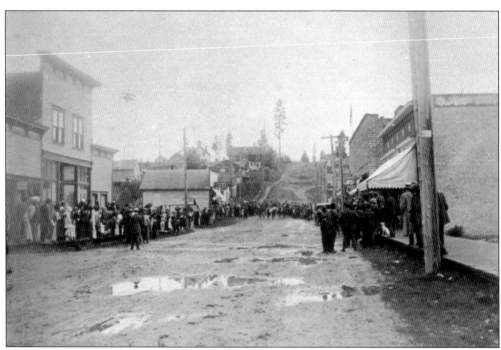

Main Street in Priest River looked dreary on this rainy day prior to 1920. A foot race was in store, probably to celebrate a holiday. The tracks up the hill in the background are now Third Street. Foot races and horse races were once popular means of celebrating an occasion. The dedication of the airport in 1931 was commemorated with a horse race.

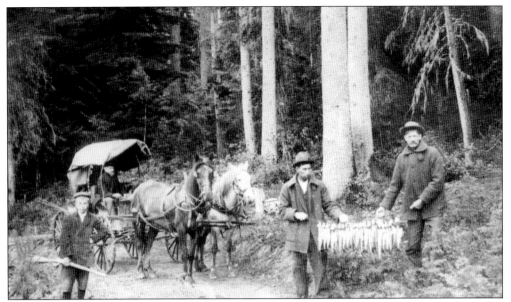

This c. 1920 photograph shows a good catch of trout. The young man with the gun is probably the senior Kenneth Shaw. William Shaw, left, holds one end of the stringer; Christian Finstad holds the other. The older man in the wagon is unidentified. These fish almost certainly came out of the Priest River near the Shaw home.

Widely known for its large Mackinaw trout, Priest Lake attracts sportsmen from all over the country. In 1958, the lake's "big mac" won the *Field & Stream* magazine contest for a 49-pound fish. Shown here from left to right with their day's catch are "Bud" Oliver, Mona Bishop, Dort McCrum, Helen Peterson, and Russell Bishop.

This c. 1914 photograph by Glenn Stewart shows a group of hunters, including many of Priest River's most eminent businessmen and professionals. From left to right are (first row) Roy Robinson, John Murray, James Runck, Robert Hydorn, Roy Kenyon, Pat Fox, and Harvey Wright; (second row) Dr. Gregory, Professor Jenkins, S.D. Sawley, Homer Redmond, Russell Hanson, William Hamberg, James Stover, Charles I. Mears, and James R. Stewart.

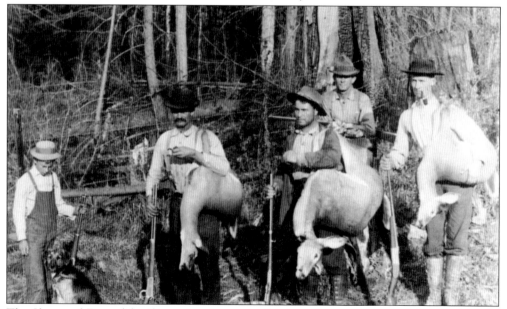

The Shaw and Finstad families enjoyed a successful day of hunting whitetail deer in this pre-1920 photograph. From left to right are Kenneth Shaw, Jacob Finstead, Paul Finstad (Jacob's son), and Christian Finstad (Jacob's brother.) The hunter in the background is unidentified.

Jonathan "Walt" Leader and his family farmed land on the peninsula northeast of Priest River. Judging by the shotguns, Walt was bird hunting in a 1931 Pontiac. The ravages of the 1931 fire, which swept across the peninsula from Freeman Lake in August, are readily apparent behind him.

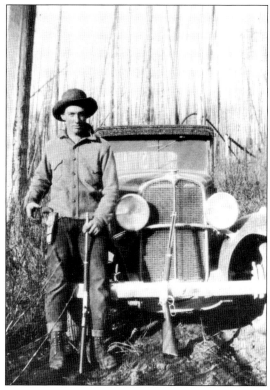

Kenneth Shaw was 12 years old when he bagged his first bear. His parents had the hide made into a rug for his room. Niece Carol Lucas remembers that all of the family's children loved to go upstairs for naps on the rug when they visited the Shaw home. The rug looked soft and comfortable, but a bear's fur is actually on the rough and prickly side, Carol said.

Ernest Peter "Pete" Morrow was one of those colorful, not always law-abiding characters for which Kaniksu Country was known. Pete was a noted trapper, bootlegger, logger, railroad section worker, and more. The last year he trapped with Leo Black, the two men brought in more than 500 coyotes in six weeks.

In 1937, Priest River High School's first football team used the "Notre Dame Shift" without any huddles to beat Cusick (Washington) 36-0 at Schaefer's Field in Priest River, where US Bank and the post office are now located. Here, Lawrence "Bud" Bryant is heading for a hole in the middle of the line.

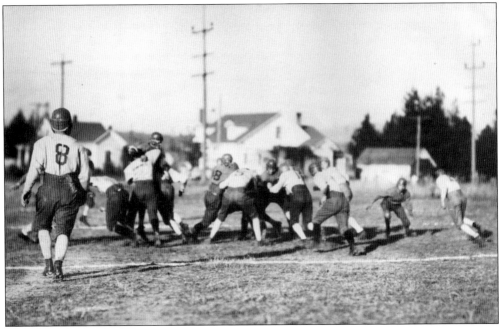

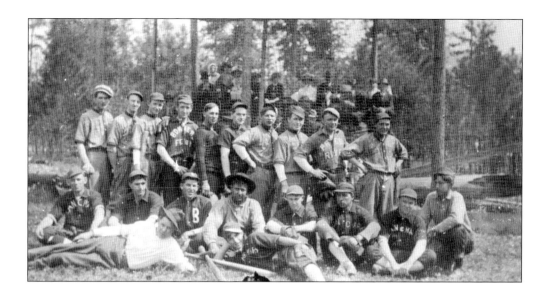

Priest River fielded some good baseball teams in its early years, and the sport is still popular. This 1915 photograph shows the Priest River and Blanchard (Idaho) baseball teams posed together. All are unidentified. The photograph below dates to around 1939. The first man on the left is unidentified, but the other three, from left to right, are "Bud" Lemley, Willard Doolittle, and Robert Doolittle. The most lauded of the local baseball players were the Hydorn brothers of an earlier era. It is said that at least one of them went on to play semiprofessional baseball in California.

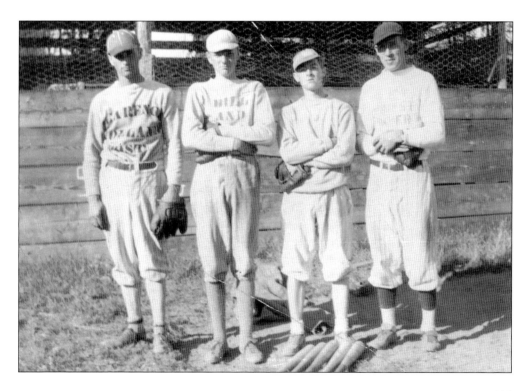

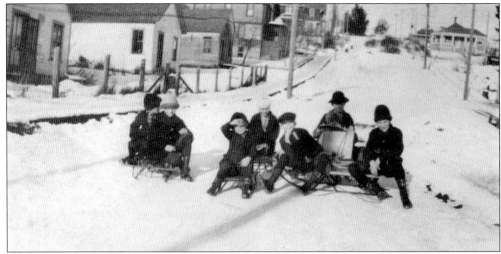

Snow coasting remains a favorite pastime of Priest River's children, but it was dangerous in the past because of the Third and Fourth Street hills. *Priest River Times* often warned of the safety issues, and finally the city leaders passed an ordinance forbidding sledding on city streets. Today's children launch their sleds at the top of the city park below Highway 2.

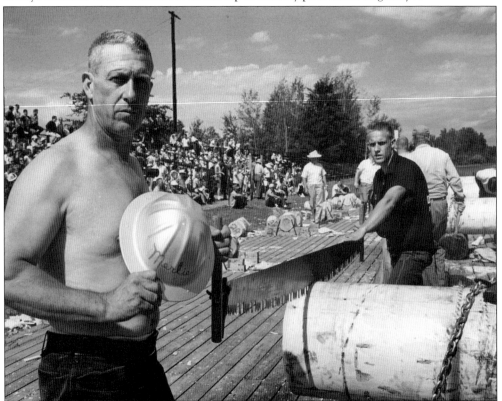

At Priest River, the name Merlie Morrow is still synonymous with "lumberjack." The crowded trophy case from his home, now a display at the Priest River Museum and Timber Education Center, attests to his mastery of the skills acquired and honed in a lifetime of wresting a living out of the woods. He is shown here with his son Ronald, competing in the Loggers Celebration.

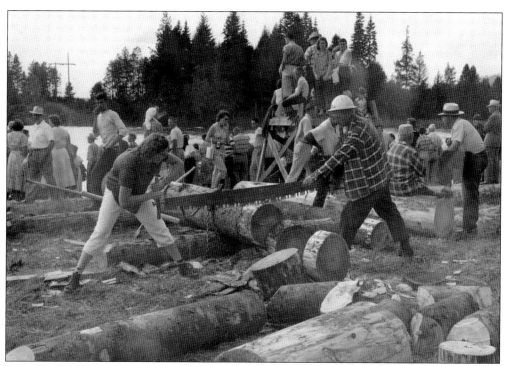

Priest River's famous competitor in logging competitions, Merlie Morrow, earned his living in woods work all his life. He began competing in 1948, and his wife, Frances (Wear), and their children followed. Eventually, he and son Ron placed third in the world championships held in Hayward, Wisconsin. In this c. 1950s photograph, Merlie and daughter Muriel (Yeaw) participate in a crosscut saw event.

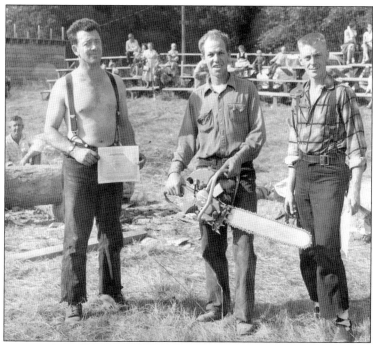

In this c. late 1950s photograph, these three men compete in the lumberjack events at Priest River's annual Loggers Celebration. Harold Reynolds, Laurence Reynolds, and young Roscoe Davenport, shown here from left to right, have just finished a chainsaw competition. Priest River held the Loggers Celebration from 1950 to 1980.

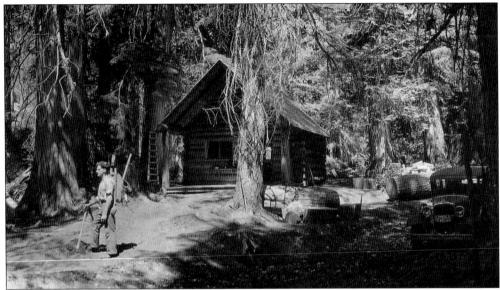

Roosevelt Cedar Grove is located 14 miles north of Nordman. A rustic campground popular with hikers and sightseers, it boasts 800-year-old trees. Throwing spray, picturesque Granite Falls cascades through rock walls with a thunderous roar. The Stagger Inn Campground was once a fire camp, and got its name because it was so remote crews were exhausted when they finally arrived and staggered in.

A challenging trail in "mountain goat country" takes one to the top of Chimney Rock for a spectacular view of the surrounding Selkirk Mountains at Priest Lake. Since the early 1930s, hikers have sought to climb this craggy peak, a landmark located on the east side. In the 1970s, world-famous mountaineers John Roskelley and Chris Kopszynski were the first to free climb the seldom seen east face, shown here.

Seven
Hard Work Yields Healthy Harvests

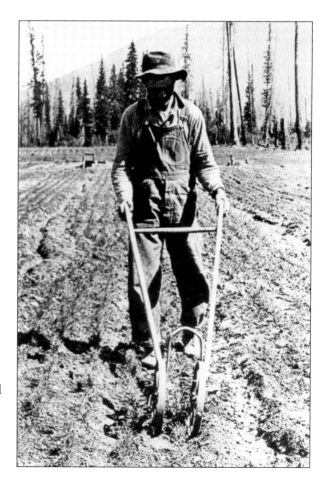

Bib overalls, a long-sleeved shirt, and a soft felt hat to shade one's arms and head from the sun were the standard garb of the early farmer, who labored without the benefit of mechanized equipment. This unidentified fellow is working his field with a cultivator used only in gardens these days, and even then not very often. Clearing timberland was back-breaking work. Removing the trees was difficult enough, but then it was necessary to deal with the stumps and roots. They were attacked with fire, stump-pullers, dynamite, horses, and any other means ingenuity could devise until mechanized equipment became available, but the process was laborious and time-consuming. Bonner County stump farms were part of the landscape for years.

Henry Keyser, known as the "Father of Priest River," crossed the Pend Oreille from Rathdrum in 1888 or 1889 with his family and purchased this property from the Kalispel Indians for a ranch just east of Keyser's Slough. This house was constructed with square nails in 1895 and moved to town in 1993. It is now the home of the Priest River Museum and Timber Education Center.

Clarence W. Herr and his wife, Marie Helene (Klehn), operated a dry goods and feed store business in Priest River but first lived on this chicken ranch outside town around 1912. The poultry house is visible on the left in this photograph. C.W. took many photographs of early Priest River and was a butterfly collector. The collection was donated to Oregon State University after his death in Oregon in 1938.

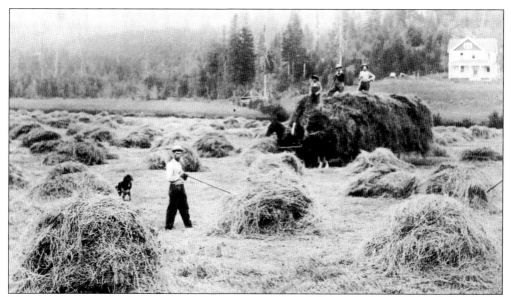

William Shaw and his brother Fred Shaw came to the Priest River valley in 1891 from Maine to help a cousin's husband, Frank Sanborn, with his ranch and cattle, then became farmers themselves. Will's big house in the background was built in 1910 after his marriage to Bertha Finstad. Here, Will stands in front of a load of hay with a pitchfork in his hand.

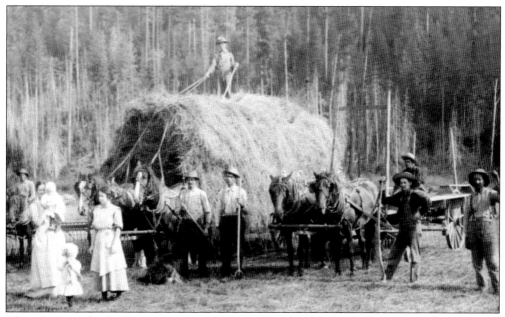

This photograph of a haying crew on William Shaw's Alderbrook Farm was taken in 1912. From left to right are Will's wife, Bertha Shaw, holding her son Kenneth, daughter Beatrice (Johnson) in front of her, an unidentified hired girl, Bertha's brother Christian Finstad, and Will Shaw. The others are unidentified.

Will Shaw is pictured here with his bull. To quote a granddaughter, "He didn't have prize winners, he just had animals." Perhaps so, but Will was no ordinary man. During the Spanish influenza outbreak that hit Priest River hard after World War II, the Shaw family escaped because he allowed no one to set foot on his property, and only he could leave it to bring back provisions.

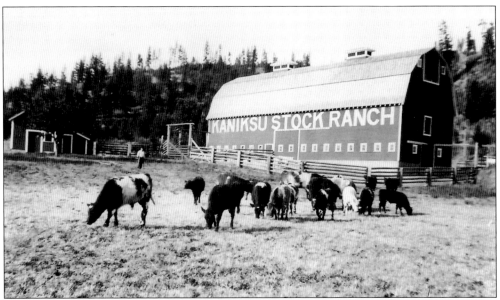

Shown here in September 1935, a year after construction, the Kaniksu Stock Ranch barn still stands in the Settlement. Charles Anselmo was the first Italian to arrive in Priest River in 1892. He settled on 108 acres of railroad property, paying for it with tie making and other labor. The ranch grew to encompass 2,750 acres, including pastureland at Laclede. It sold for development in 2005.

Charles's son Frank Anselmo Sr. sold John Deere tractors and other farming equipment from the Kaniksu Stock Ranch in the Settlement at Priest River for 20 years. This c. 1948 photograph shows Frank's daughter Naida (Miller) and her cousin "Shockie" (William Hungate) on one of the ranch's tractors.

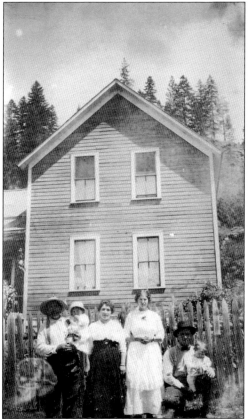

Charles Anselmo, on left holding a child, stands with unidentified family or friends in front of his home. Charles's son Frank Sr. operated Kaniksu Tractor and Implement at the ranch from 1926 to 1946, then moved the business to town. He and his family moved into Priest River also in 1947. Frank's son Harold then operated the ranch until turning it over to his sons Thomas and Steven when he retired.

This c. 1944 photograph of a haying crew on the Kaniksu Stock Ranch included six Naccaratos. Shown from left to right are Charles, Robert, Roland "Buddy," Kenneth, George, and Gus. Charles Anselmo, who founded the ranch, died in 1947. He had assisted his son Frank Sr. with its operation for many years. The ranch endured in Anselmo hands from 1892 to 2005.

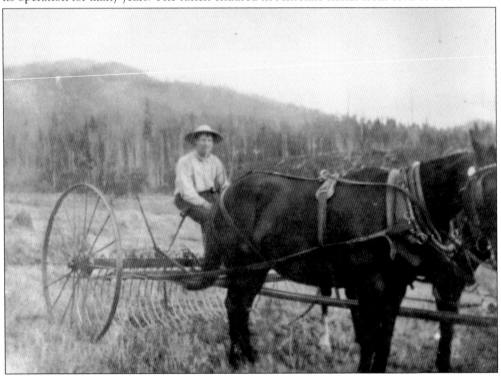

With its short growing season, the Priest River area never became the agricultural mecca many of the early settlers hoped for. Times changed, hay crops continue to do well, especially with a sprinkler irrigation system (if one does not expect more than two crops a year). Benton "Babe" H. Prater is shown here on a dump rake northeast of Priest River long ago.

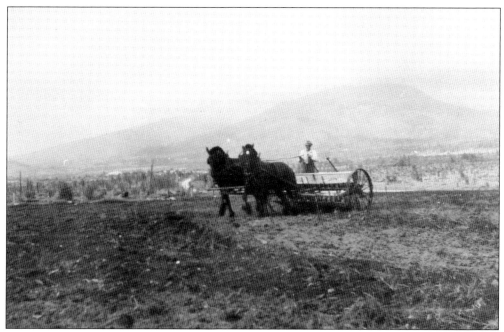

William "Bill" Leader is shown here around the late 1930s, either seeding a field on the peninsula or spreading manure. The Leader family came to the Priest River valley by wagon in 1932. The Dust Bowl and the Depression combined to bring about a great exodus of farmers from the Midwest.

In this c. 1940 photograph, the members of the peninsula 4-H Calf Club are, from left to right, Robert Smith, Richard Hammons, Margaret Hammons, and Calvin Holley. The Bonner County Fair in Sandpoint culminates the 4-H year. The 4-H clubs have long been a feature of life in Bonner County, and livestock projects are the leading favorites yet today.

Earl Perin, a lumber truck driver seriously injured in an accident in 1960 at Diamond Match's sawmill in Cusick, Washington, spent 30 years helping breed back the Nez Perce Indians' spotted war ponies, whose bloodline had almost been obliterated. Perin developed his own line of "true Appaloosas," known as the Toby-Red Eagle line, at his Priest River ranch.

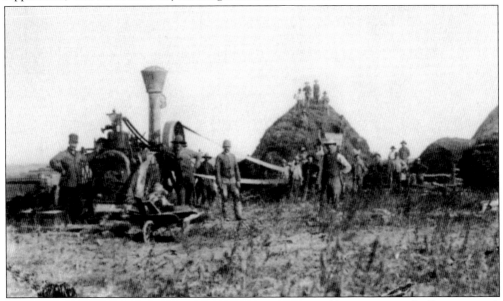

This threshing machine with an unidentified crew is shown blowing grain chaff into a stack on the Shaw ranch, Alderbrook Farm. The owner of this machine is unknown but it could have been Henry Keyser Jr., who did contract threshing for farmers up and down the Priest River valley. Not every farmer would have owned a threshing machine because of the costs involved. Combines replaced them.

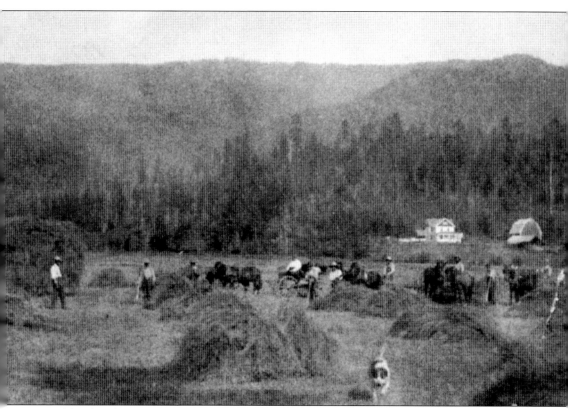

Owned by the Shaws, Alderbrook Farm looked like this in haying season sometime between 1910, when the big house was built, and 1915. The barn is the hip-roofed building to the right. At harvest time, it was always the duty of the farmer's wife—and anybody she could enlist to help her—to cook the noon "dinner" and feed all the men. The evening meal was called "supper."

Discover Thousands of Local History Books
Featuring Millions of Vintage Images

Arcadia Publishing, the leading local history publisher in the United States, is committed to making history accessible and meaningful through publishing books that celebrate and preserve the heritage of America's people and places.

Find more books like this at
www.arcadiapublishing.com

Search for your hometown history, your old stomping grounds, and even your favorite sports team.

Consistent with our mission to preserve history on a local level, this book was printed in South Carolina on American-made paper and manufactured entirely in the United States. Products carrying the accredited Forest Stewardship Council (FSC) label are printed on 100 percent FSC-certified paper.